SAN FRANCISCO
BEER

A HISTORY OF BREWING BY THE BAY

BILL YENNE

Foreword by Shaun O'Sullivan, 21st Amendment Brewery

AMERICAN PALATE

Published by American Palate
A division of The History Press
Charleston, SC
www.historypress.net

First published 2016

ISBN 978.1.5402.1369.3

Library of Congress Control Number: 2015957667

Notice: The information in this book is true and complete to the best of our knowledge. It is offered without guarantee on the part of the author or The History Press. The author and The History Press disclaim all liability in connection with the use of this book.

CONTENTS

Foreword, by Shaun O'Sullivan 5
Acknowledgements 9
Introduction. A Pearl Without Peer 11

1. The Formative Years 15
2. A Growing Industry 33
3. Into a New Century 49
4. The Rise of the Regionals 61
5. The Origins of Craft Brewing 75
6. Craft Brewing Comes to Stay 85
7. Into the Future 103

Appendix I. Commonly Used Abbreviations 133
Appendix II. Measurements 135
Index 137
About the Author 143

FOREWORD

The Bay Area has long captured the American ideal of the "Land of Opportunity" as a magnet for settlers, prospectors, seekers and the like. Like those who first put their feet on this soil to gain a fortune during the 1849 Gold Rush, many of us are here to experience something that we could not find from where we originated.

From the early settlers who traveled on the first transcontinental train west to those who became part of the 1960s music scene with the Grateful Dead and Jefferson Airplane, there is no shortage of ordinary or famous people who have found what they were looking for in the Bay Area. Some went on to create big opportunities for thousands of others in the Bay Area and beyond; Steve Jobs, Steve "Woz" Wozniak, George Lucas and Francis Ford Coppola are now household names in the Western world. And those of us in the brewing industry surely remember when Fritz Maytag, who some consider the father of the modern microbreweries, purchased the historic Anchor Brewing Company.

The Bay Area gives us all a place to land our creative and prospective ideas and to reinvent ourselves while also scratching our itch for opportunity and, hopefully, success. The San Francisco brewing community, then and now, is part of this very framework, giving another layer of richness and depth to the ever-changing and vibrant Bay Area community, offering the people a needed and desired social elixir.

Brewers don't make a "product." That word is reserved for producers of ball bearings and disk drives. We make beer, and we do it well. In San

Francisco, we get to use near-perfect water tunneled to San Francisco from the Hetch Hetchy reservoir near Yosemite. Like water, beer is a living beverage, ultimately brought to us by the real microbrewer, yeast. That single-celled aerobic organism performs that magical act of fermentation, producing alcohol and carbon dioxide by scavenging the sugar supplied by the malt upstream in the brewing process, balanced with the aroma and bittering compounds of hops.

When starting our brewery fifteen years ago in the historical SOMA neighborhood, we looked to the old San Francisco white pages for an inspirational name and came across the likes of breweries at that time that bore monikers such as the Eagle Brewery or the Hibernia Brewery—all historically significant, but they didn't grab my business partner, Nico Freccia, and me as names that we could hang on a shingle. We realized we were floating in an era that was tied to the start and end of Prohibition, with the passage of the Twenty-first Amendment to the U.S. Constitution.

We took that name and made it ours. To us, it celebrates the demise of the "noble experiment" and the gradual return of the pub and brewing culture

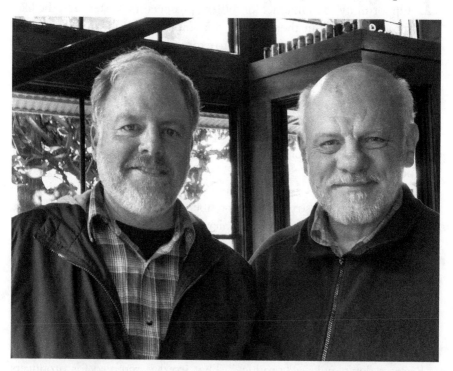

Shaun O'Sullivan (left) with the author at the 21st Amendment Brewery. *Author's collection.*

to the Bay Area and the community that came with it. The name further found us as we scoured the SOMA neighborhood for a viable location that could house a small production brewery with a restaurant. No other name seemed suitable to evoke our character. With our location on Second Street, a former coffee roastery and warehouse space, in the thick of the early San Francisco brewing community, we had landed.

Bill Yenne records and delivers an elegant view of San Francisco's brewing history. He gives us a front-row seat to our great city's brewing past and current progress. From the early wave of breweries populating the city to consolidations in the late 1800s and 1900s to the first and second explosions of modern craft breweries, Yenne has laid it all out before us as a tapestry of successes and struggles. What a long and winding road it has been. Grab a beer and enjoy this historical ride.

<div align="right">

SHAUN O'SULLIVAN
Co-Founder and Brewmaster, 21st Amendment Brewery

</div>

ACKNOWLEDGEMENTS

The author wishes to thank all those who have generously provided their time, referrals and stories and the useful information that made this book possible, as well as to all the brewers who took the time to speak with me in the course of this project and certainly those who offered to buy me a beer. I would especially like to mention Joanne Marino of the San Francisco Brewers Guild, Richard Brewer-Hay, John Dannerbeck, Brenden Dobel, Rich Higgins, Dr. Tom Jacobs, Dave McLean and Brian Stechschulte. A nod is certainly due to Allan Paul, gone from the San Francisco brewing scene but certainly still alive in the minds of many, especially this author. Finally, special thanks to Shaun O'Sullivan for penning the foreword and to Fritz Maytag, who has shared so many wonderful tales of the world's last medieval brewery and how it became America's first craft brewery.

Introduction

A Pearl Without Peer

S an Francisco is one of those magical world cities—like Venice or Constantinople or New Orleans—whose historical reputation is equal parts poetry and commerce. It originated in the 1830s as a tiny cluster of buildings on the shore of a cove called Yerba Buena, about three miles from an old Spanish mission that had been dedicated by Franciscan friars to San Francisco de Asis (St. Francis of Assisi) in that auspicious year 1776.

The cluster of buildings became a town, and as trading ships arrived from the outside world, the town began to take the form of a little seaport. The town originally took its name from the cove, which took its name from *yerba buena* (Spanish for "good herb"), an aromatic plant that was plentiful in the area.

As the clipper ships called in Yerba Buena on their way to and from the Eastern Seaboard of the United States and the Far East, they brought with them the finer things of those more extensively developed civilizations. Among those finer things was beer. One of the earliest known documents confirming this is an "Invoice of Merchandise" in the collection of the California Historical Society that is dated September 20, 1843. It records a consignment of bottled beer that was shipped to Yerba Buena by the firm of the Boston merchant Benjamin T. Reed.

Yerba Buena was much smaller than Monterey, about one hundred miles down the coast, which was the Spanish capital of California and the principal trading city, but it was blessed with a fine natural harbor and began to grow. By the time it was officially renamed San Francisco after the patron saint of the mission in 1847, the little community boasted a population of

459 by the reckoning of Sam Brannan, the publisher of the *California Star*, the town's first newspaper. Of these, over half were Mormon immigrants who had arrived with Brannan himself in July 1846.

San Francisco might eventually have become a city of some minor regional importance, but by quirk of happenstance, it became the largest and most commercially important city west of the Mississippi River, a distinction that it retained until well into the twentieth century.

In January 1848, something happened that changed the history of San Francisco and the American West. It was not in the city, but at a place about 130 miles to the east, near Coloma in the Sierra Nevada foothills, at the sawmill owned by a Swiss emigrant and pioneer entrepreneur named Captain John Augustin Sutter. Here, a Sutter employee named James Marshall picked a large piece of solid gold off the ground—and then another and another. Soon it was discovered that gold could be found just lying around throughout the region.

No sooner had the news of the gold discovery reached San Francisco than there was a stampede of would-be prospectors from the city to the gold fields. The *California Star* and the rival *Californian* both ran the story and then closed down—in June and May, respectively—as their staffs abandoned the press rooms for the placers of the Sierra foothills. Sam Brannan did not mind; he quickly reinvented himself as a merchant, and in nine weeks, he made more than $1 million in today's valuation selling shovels and gold pans to the prospectors. By 1849, when the great Gold Rush swept into California, he had a chain of stores that earned the modern equivalent of more than $4 million a month.

Almost overnight, the tiny village of San Francisco became a world-class metropolis, a bustling and glittering jewel of a city, a pearl without peer at the remote edge of the continent, two thousand miles from what most Americans defined as civilization. There were those who became fantastically wealthy in the gold fields, others who merely did well for themselves and others who wound up as failures. The largest fortunes, though, were earned by the merchants who provided the supplies, men like Brannan and Levi Strauss, who invented a type of hard wearing, riveted trousers and created a brand that still has a following in the twenty-first century.

Of course, the biggest winner in the 1849 Gold Rush was the new city of San Francisco, through which the Forty-niners had to pass in order to reach the Sierra Nevada and in which they lingered and provisioned. San Francisco Bay, which was used to being visited by the occasional merchant ship, was suddenly a veritable forest of masts. By the end of 1849, the population

of San Francisco exceeded 25,000, and by the 1852 census, 34,776 called it home. From there, it nearly doubled to 56,802 in 1860 and more than doubled again to 149,473 by 1870.

Thanks to both those seeking riches and those returning from the mountains with the flakes of the yellow metal overflowing from their pockets, the demand for accommodations and for purveyors of general merchandise was insatiable. The shops were not merely of the pick and shovel variety but were world-class emporia for jewels and finery that one would be accustomed to finding the New York or Chicago—or even London or Paris. Those passing through San Francisco, as well as its increasingly well-heeled residents, also demanded the best in dining establishments, gaming venues and watering holes.

Even before the Gold Rush, the influx of people familiar with beer led to a demand for it, and it was a demand that could not be solely satisfied by the expensive and intermittent stocks that arrived aboard the clipper ships. As necessity is the mother of invention, there was a critical demand for people who could and would brew beer. As San Francisco was rapidly evolving as the metropolis of the West, this set the stage for the city to become the most active and robust brewing center anywhere in the American West.

1

THE FORMATIVE YEARS

S an Francisco was destined to become the brewing capital of the West, but where did this all begin and with whom? The search for the first commercial brewer in San Francisco is a bit like a search for that illusive ten-ounce nugget in the Sierra Nevada and very much like a good detective story.

On matters concerning the history of the Golden State in the mid-nineteenth century, one naturally starts with Hubert Howe Bancroft, whose massive, meticulously detailed, seven-volume *History of California*, published between 1884 and 1890, is considered the definitive work. In it, Bancroft introduces us to the inimitable "Billy the Brewer," a colorful character whose name rolls off the tongue like that of the likes of Johnny Appleseed or Davy Crockett, an individual who is equal parts myth and legend.

Billy, whose name is an inexorable part of the narrative of brewing in California, was an Irish seaman whose real name was William McGlone, though the surname is also seen spelled McGline or McGlove. In June 1837, he shipped out from New Bedford, Massachusetts—then known as the Whaling City—aboard the 298-ton whaling ship known as the *Commodore Rodgers*. In November, the ship put in at Monterey and was in port when a powerful off-shore storm blew in and damaged the vessel. Two weeks later, after repairs were done, the ship set sail only to run into another tempest in which the *Commodore Rodgers* lost most of its masts and sails. The captain ran it aground in order to save nine hundred barrels of whale oil, but the ship was a total loss. The cargo was sold off at public auction, the ship was scrapped and the crew was stranded.

William McGlone found himself in Monterey, drifting from job to job. Among the highlights confirmed by Bancroft and others are that he worked at the soap factory of pioneer merchant and United States consul Thomas O. Larkin. During the Mexican War, Billy joined the American California militia and was wounded in action at the Battle of the Natividad, a skirmish that took place in November 1846 in the Salinas Valley, not far from Monterey.

That he was an eccentric there is no doubt. Bancroft wrote, "I have his letter of '44 in which he complains that he has been seven days in jail without food!" Bancroft doesn't say what he'd been arrested for.

During the early 1840s, McGlone was also employed by California pioneer Isaac Graham, who operated a distillery and sawmill at Rancho Zayante in the Santa Cruz Mountains near present-day Felton. It was here that he likely had his introduction to the art and science of fermentation. Because wine had long been widely produced, a distillery at this time would have most likely been a producer of spirits derived from grapes, such as brandy or aguardiente.

Of course, fermented beverages were being made in California long before the first fisherman's shacks were built in Yerba Buena and even before the establishment of Mission San Francisco. Wine had been produced since the mission period began in 1769 in "Upper" or "Alta" California (the present state of California, as distinguished from "Lower" or "Baja" California, now in Mexico). With that, there naturally followed distillates with higher alcohol, which included brandy from wine grapes and "aguardiente," a term that is literally translated as "fire water," which originated in rural Spain and is still used to describe a wide variety of spirits made through the fermentation of many different fruits or vegetables other than grapes. Like brandy, aguardiente ranges from around 20 to over 60 percent alcohol by volume (ABV). There is also mention in pre–Gold Rush pioneer accounts of "California whiskey."

In 1848, McGlone was among those who followed the Gold Rush into the Sierra foothills. John Alfred Swan, an English sailor who settled in Monterey, may have known McGlone in that city, but he certainly knew him in the mountains. In his 1870 memoir, *A Trip to the Gold Mines of California in 1848*, Swan wrote, "He brewed beer for a very short space of time but had to give it up as unprofitable, since the Californians preferred aguardiente; but his nickname, 'Billy the Brewer,' remained with him for life."

By 1857, Billy was back in Monterey with no mention of his having spent any length of time in San Francisco. He drowned off Santa Barbara some time after 1858.

Billy's name has become inexorably linked to the folklore of early San Francisco brewing and is often and easily recalled in other accounts that reference Bancroft. However, while Bancroft said that Billy was a brewer and Swan said that he brewed briefly around 1848, neither of them actually identified Billy the Brewer as the first man to brew beer commercially in San Francisco, nor did they say that he ever even brewed in the city.

If Billy the Brewer was not the first commercial brewer in San Francisco, who was it? There are a number of theories. We return again to Bancroft, who, after tantalizing us with the eccentric Billy, writes that around 1850, "on Second [Street], near Mission [Street], rose the Empire Brewery of W[illiam] Bull, the first of its kind." He does not define what he means by "the first of its kind," though he implies that he believed the Empire to have been the first brewery in San Francisco.

Meanwhile, Don Bull, Manfred Friedrich and Robert Gottschalk, in their encyclopedic book *American Breweries*, list William Bull's Empire Brewery, as well as Adam Schuppert's California Brewery at Stockton and Jackson Streets, as having started in the Gold Rush year of 1849, but they identify Schuppert's as having been the first.

Given this abundance of contradictory evidence, where does the search lead in the quest for the first brewer in San Francisco? We must turn now to a man who took up residence in San Francisco when it was still Yerba Buena and when Hubert Howe Bancroft was still a teenager working in his brother's bookstore in Buffalo, New York. One of San Francisco's earliest pioneers, John Henry Brown, is the man who knows.

Brown was an English adventurer who had worked as a trapper and trader in the Mountain West from 1843 through 1845. He arrived to settle in San Francisco in January 1846, six months ahead of Sam Brannan and six years ahead of Bancroft. He came to the city when it was still Yerba Buena, had no named streets and would have been easy to get to know, at least in passing, everyone in town. In turn, he met and knew many others as they arrived, and he documented them and his interactions with them in his priceless 1886 book *Reminiscences and Incidents of the Early Days of San Francisco*. Among those whom he knew, and about whom he later reminisced, was San Francisco's first commercial brewer.

Brown wrote:

> *There are many persons who claim to have started the first brewery in this city; but Francis G. Owen is the only one who can claim that honor. He built what would be called now a small brewery, on the corner of Pacific*

and Dupont Streets. Mr. Owens arrived in this country in 1845. He came to Yerba Buena, and purchased a 50 vara lot [approximately one-sixth of a city block], *and then returned to Sutter's Fort and remained there until the early part of 1846. He came from the same town as Captain Sutter, and brought him news of his wife and family. Captain Sutter sent for his family, and they arrived in this country in the year 1850. Owens left this country for his native place, in 1852, and I have been informed, that soon after his arrival at home he died.*

Unfortunately, Owen (or Owens) does not correspond directly with any other accounts of such an individual in Yerba Buena at this time. On this point, this author is deeply indebted to San Francisco brewery historian Dr. Tom Jacobs, who points out that Brown, for all his powers of observation, was a horrible speller. Not only did he refer to William A. Leidesdorff, San Francisco's one-time richest man, as William A. Leidsoff, but he also used the phonetic spelling for the name of the city's first brewer, calling him Francis G. Owen instead of Francis G. Hoen. Under the latter name, Francis shows up in numerous accounts, including those of Bancroft.

The fact that "he came from the same town as Captain Sutter" confirms the Germanic surname. It was originally punctuated as Höen and pronounced like "Hern" but was then anglicized to Hoen, which was pronounced to rhyme with "Owen," the name by which Brown knew him. Sutter was born in Kandern in the Duchy of Baden (now in Germany) but spent most of his life before emigrating to America in Neuchâtel and Burgdorf in the German-speaking part of Switzerland.

Confirming what Brown wrote, Bancroft listed Francis Hoen among the "Pioneers of 1845," adding that he arrived in Yerba Buena as part of the emigrant group led by William Swasey and William Todd that had traveled overland from Oregon after crossing the continent on the Oregon Trail. Bancroft goes on to say that Hoen originally lived in the block bounded by present-day Pacific Avenue to the west, Montgomery to the north and Sansome to the east. At that time, the block fronted San Francisco Bay on the south, and Hoen's house overlooked the water.

Both Bancroft and Brown recalled a famous incident that occurred on the block. As Bancroft tells it, there was "an adobe building occupied in [1847–49] by A.J. Ellis as a boarding-house and groggery. Everybody remembers how a bad taste in [Ellis's] whiskey led to the discovery of a drowned Russian sailor in the well."

In the meantime, Hoen had opened his brewery two blocks to the west of the Ellis block and two blocks north of Portsmouth Square, the civic and commercial center of the city of San Francisco. Both Brown and Bancroft agree that Hoen was here at the northwest corner of Pacific and Dupont (now Grant Avenue), a few doors from the Shades Tavern, which had a bowling alley on the premises and was certainly a good customer for Hoen's beer.

A compilation of San Francisco statistics published in the *California Star* on August 28, 1847, and reprinted in the *Californian* a week later lists the occupations or professions of the men residing in the city at the time. Among the many trades cited, there were twenty-six carpenters, seven bakers, six blacksmiths, six inland navigators, three doctors and three lawyers but just one cigar maker, one Morocco leather craftsman and one brewer. That man was Francis G. Hoen.

In the meantime, Hoen was becoming a prominent citizen, or at least trying. In reporting the results of the September 15, 1846 municipal election, the *Californian* notes that he had run for city treasurer, though he was defeated sixty-seven to twenty by John Ross. He continued to dabble in politics, and in 1849, he ran unsuccessfully for the district legislature.

In glancing through the back issues of the San Francisco papers for these years, one also notices numerous advertisements placed in 1848 by "Francis Hoen, Brewer," promising to pay "the highest price" for hops. This clearly indicates a thriving business for the first brewer in San Francisco. It is not known why, or whether, Hoen left San Francisco for Europe in 1852 as Brown reported. He did, however, fade from view and the pages of the local papers. He had likely departed before Bancroft arrived, also in 1852. If this narrative were to be adapted for the silver screen, there would certainly be a scene in which the two men passed each other on the gangplank, with Hoen boarding the ship as Bancroft disembarked.

By 1849, fueled by Gold Rush–era demand, other breweries—including the Empire Brewery of William Bull and the California Brewery of Adam Schuppert—had begun to crop up throughout the city. The 1850 city directory, which recorded the businesses active in 1849, lists Bull's Empire but not Schuppert's establishment. It does, however, list another California Brewery on Vallejo Street between Powell and Mason Streets owned by John Neep. Though little is heard of Schuppert in the ensuing decades, his commercial demise seems to have come in 1867. There is a notice in the *Alta California* newspaper reporting of a July 10 sheriff's sale of his property in San Francisco and elsewhere.

HOPS! HOPS!

The subscriber will pay the highest price for Hops, in large or small quantities. Any one having Hops which they wish to dispose of will do well to call on the subscriber **FRANCIS HOEN**, Brewer.
San Francisco, Sept. 23, 1848, 8–b

SHADES TAVERN.

This well known establishment has been re-opened with a large and superior assortment of Brandy, Wines, cordials, cigars, &c. which will be sold in quantities of from one bottle or case, to a pipe of 60 gallons, as may suit purchasers.

The favorite Bowling Alleys attached to the house will be constantly upon for the amusement of the public, who are respectfully invited to call and examine for themselves.

Terms—cash, or Gold Dust at sixteen dollars per ounce.
San Francisco. Sept. 16. 1848. 7–tf

San Francisco's first brewery was operated by Francis G. Hoen, who placed many newspaper ads in an effort to obtain hops to meet the demand for his beer. This one appeared in the *Californian* in October 1848. The famous Shades Tavern was on the same block. *Author's collection.*

In the 1850 directory, Ambrose Carner is listed as a "beer manufacturer" located on Sacramento Street between Stockton and Powell. G.F. Joseph on California Street is mentioned in conjunction with the terms "Ale and Porter," which makes it appear that he was a merchant who dealt in beer that was shipped in from elsewhere.

The pairing of Bull and Schuppert as being among the first brewers is illustrative of another fact about the early breweries in San Francisco: the brewing traditions their brewers had learned were not homogenous. Schuppert, like Hoen, was of the German tradition, while Bull was either an Englishman or an American from the East, where he would have been trained in the British tradition of ale and porter. Though German immigrants would eventually come to be predominant among San Francisco brewers, San Francisco had the benefit of both traditions in its early days.

The Scottish journalist and world traveler John David Borthwick, who was in San Francisco and the Sierra gold fields between 1851 and 1854, spoke of this fact, albeit in a not-so-complimentary way. He wrote in his book *Three Years in California* that San Francisco had one licensed saloon for every one hundred persons, estimating that it had proportionately the greatest number of drinking places of any city in the world. He wrote of his personal field studies in "second-rate English drinking-shops" where one could "swig his ale," and of the German beer cellars, where he griped about "the noise and smoke which came up from them." He did capture an image of San Francisco tavern culture that is corroborated in so many other memoirs of the period.

However, the city was not just a tumult of hard-drinking prospectors and crusty seamen. Beer was also a staple on the family table. For this, we turn to the correspondence of Mary Jane Megquier, whose letters were collected into a book called *Apron Full of Gold* that was produced in 1949 by Robert Glass Cleland. In a note to her daughter that was dated November 30, 1849, Megquier wrote of a "nice thanksgiving dinner yesterday" during which her guests had commented that "they had no idea there could be so good a dinner got up." The drinks served included "porter and ale."

Perhaps it had been imported from England or Boston, or perhaps it was from William Bull's Empire Brewery.

MANY BREWERIES CAME AND went as San Francisco grew rapidly during the Gold Rush era, some well documented and others long forgotten. There were at least fifteen well-established breweries in the city by 1856, and the city was the major brewing center in the West. San Franciscans had developed a reputation for being self-sufficient and self-reliant. Until the completion of the Transcontinental Railroad in 1869, they were cut off from the rest of the United States by a treacherous ocean voyage that could take up to half a year. Self-reliance meant that San Francisco had become a brewing center whose importance rivaled that of Cincinnati or St. Louis.

LION CO.
BREWERY.

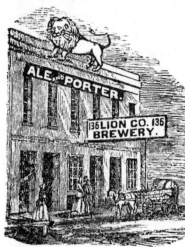

ALE AND

PORTER.

136 Pine Street, between Montgomery and Kearny,
SAN FRANCISCO.

AGENCY, SAM. DOAKE, NO. 57 K STREET, SACRAMENTO.

The above Brewery is the most complete in the State, and pro-
duces a Beverage of a most superior quality.

ALE AND PORTER,

In WHOLE and HALF PACKAGES, constantly on hand, and
all Orders promptly filled.

☞ The INTERIOR TRADE supplied on the most accommodating
terms, either by the Agents of the Company, or direct from the
Brewery.

☞ Inquire for Lion Company Ale or Porter.

This advertisement, including a good illustration of the Lion Brewery, appeared in the San
Francisco city directory of 1856. *Author's collection.*

The earliest breweries were situated primarily in two areas, one near the bay in North Beach and the other near the bay south of Market Street.

Following the lead of Hoen and Schuppert, there was a concentration in the areas north and west of Portsmouth Square that came to be called North Beach. In the early days, before extensive land fill, the area of San Francisco Bay that is now the Financial District was still part of San Francisco, and North Beach was an actual beach. Close to the port, as one walked into the North Beach neighborhood, one would pass the Golden Gate Flour Mills. Erected by B.F.D. Conro in 1853 on Pine Street between Montgomery and Kearny Streets, it was advertised in the city directories as operating, among other things, "an extensive brewery." By 1856, this extensive brewery had hung out a sign identifying itself as the Lion Brewery and another touting its "Ale and Porter," as well as a huge lion perched atop the building.

A few blocks farther north, in the heart of North Beach and on adjacent Telegraph Hill, the early businesses included the Bavarian Brewery of Jacob Gundlach and Philip Frauenholz on Vallejo Street, which opened in 1852. In 1853, another German immigrant named Jacob Specht started his San Francisco Brewery, the first of many with that obvious name. His original building was at 126 Broadway near Stockton, but he built a larger building in 1859 at 91–99 Broadway (later renumbered as 629–37).

Specht had at least two partners at the site, the last being Joseph Albrecht, who came into the business in 1861. In turn, Albrecht bought Specht out. In 1862, Albrecht took a partner himself, a man named Johanas Adami. Albrecht and Adami renamed the facility the Broadway Brewery. Between 1862 and 1864, Specht operated another operation, the Mission Brewery, nearby at 525 Pacific.

Another entrepreneur who arrived in North Beach during the 1849 Gold Rush was John Mason, whose name crops up in San Francisco brewing lore through the end of the century. Mason's name is also associated during this time with whiskey distilling. In 1854, he started his Eureka Brewery and Distillery at the northeast corner of Stockton and Union, and through the coming years, he was associated with various other breweries, including his Mason's Brewery on Chestnut Street, which operated between 1874 and 1884. He also established the whiskey distillery at Waldo Springs—later known as Whiskey Springs—in Sausalito that was last operated by the American Distilling Company from 1933 until in burned down in 1963.

Two other North Beach breweries starting in 1859 were that of Herman Sulitz at 511 Green Street and Claus Wreden's Washington Brewery at 723–

25 Lombard. Yet another was the Berlin Brewery at the corner of Powell and Chestnut in the northern part of North Beach.

The second early concentration of breweries was located roughly in the area south of Market Street that lies between First and Fourth Streets. Then known as Happy Valley, it is now the northeast corner of the large area known as "South of Market," or simply "SOMA."

One of the first brewers south of Market Street was Adam Koster, who started brewing on Mission Street in 1853 but moved a short distance to Clementina Street between Fourth and Fifth in 1858. A Clementina Street neighbor was Christian Hess's Union Brewery. Another neighboring firm was the Empire Brewery, operated by Lyon & Company at 106 Jessie Street between Third and Fourth. It may or may not be associated with William Bull's Empire Brewery of 1849. Lyon's Empire Brewery also operated a malting operation in North Beach on Chestnut Street between Powell and Mason that survived in various hands for many years.

In 1860, a young Irish immigrant named Anthony Durkin, who had worked as a teamster for the Empire Brewery, started his own business, the Mission Street Brewery at 608–10 Mission Street near Second, in partnership with a fellow Irishman named Charles Armstrong. This enterprise would be haunted by the 1861 death of the seven-year-old daughter of an employee, who fell into a brew kettle at full boil.

There were at least two Cincinnati breweries in San Francisco. According to *Colville's San Francisco Directory*, Jaiger & Company, on Post Street between Mason and Taylor Streets north of

John Wieland, San Francisco's great nineteenth-century "beer baron," arrived in San Francisco in 1851 and entered the brewery business 1855. *Bill Yenne illustration.*

An advertisement for John Wieland's sprawling Philadelphia Brewery complex on Second Street. He lived next door to the brewery. *Author's collection.*

Market, was established in 1855, predating Adam Meyer's Cincinnati Brewery on Third Street, near Howard, south of Market, which appeared in city directories by 1858.

John Wieland, San Francisco's great nineteenth-century "beer baron," came on the scene in 1855 through the acquisition of an interest in August Hoelscher's Philadelphia Brewery. This business then moved into a new plant in Happy Valley at 228–46 Second Street between Howard and Folsom in 1856.

Born in the German kingdom of Württemberg in 1791, Wieland had immigrated in 1849 to Philadelphia, where he worked as a baker before being bitten by the California "gold bug." He settled in on the south fork of the Yuba River and was one of those who did well on the placers. In 1851, he cashed in, moved to San Francisco and again went to work at a bakery. Within six months, he owned the business. Four years later, he traded baker's yeast for brewer's yeast.

With Wieland as the sole owner after 1867, the Philadelphia Brewery became San Francisco's largest of the nineteenth century, not only in terms of production volume but also in the size of its physical plant. It had a 215-foot frontage on Second Street and a footprint of nearly 60,000 square feet.

Hoelscher, meanwhile, went on to operate his South San Francisco Brewery on Fourteenth Street. Confusingly, it was not in the city of South San Francisco, which was not incorporated until 1908, but rather the southern part of what is now San Francisco, which was not originally within the city limits.

John Wieland went on to a respected role as an important member of society. According to the *Bay of San Francisco*, produced in 1892 by Lewis Publishing without a credited author, he was "favorably known as one of San Francisco's most progressive business men [and] was the founder and proprietor of the Philadelphia Brewery, which grew from a small beginning to be one of the leading industries of the city."

As FOR THE RELATIVE quality of the beer being produced by San Francisco's brewers and how it was perceived at the time, we may return to September 1857 and relish at least the memory of the First Industrial Exhibition of the Mechanics Institute of the City of San Francisco. The trade fair featured exhibits from all of the city's industries, which, naturally, included breweries that chose to present their wares for sampling. In the exhibition report, we learn that John Mason entered six bottles of porter, which were acknowledged as "a very good article, from the Eureka Brewery, and considered the best

Right: Claus Spreckels, who operated his successful Albany Brewery on Everett (now Natoma) Street, aspired to be a beer baron in the mold of John Wieland but found his niche in sugar and cornered the trade between California and Hawaii. *Author's collection.*

Below: This advertisement provides a good look at the Albany Brewery of Claus Spreckels. He later became wealthy in the sugar business. *Author's collection.*

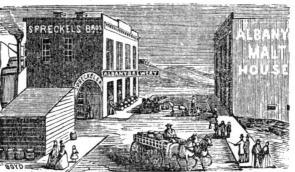

ALBANY BREWERY,

SPRECKELS & CO., Proprietors.

71, 73 AND 75

EVERETT ST.

Between Third and Fourth, SAN FRANCISCO, CAL.

This Establishment has been enlarged for the third time, and now possesses facilities unsurpassed by any competition for the production of

SUPERIOR CREAM ALE,

To supply the increasing demands of the public.

exhibited." Lyon & Company of the Empire Brewery presented "a half barrel of porter," which was called a "little inferior to the preceding sample" but that nevertheless earned them a bronze medal. In the lager category, the two kegs and two dozen bottles that Adam Meyer brought to the exhibition from his Cincinnati Brewery earned him a diploma declaring them the "best." John Wieland's Philadelphia Brewery is noted only for having entered a barrel of lager.

One of Wieland's biggest early competitors was Claus Spreckels, a German immigrant who was to become one of San Francisco's most historically prominent businessmen. He arrived in San Francisco in 1856 by way of New York and South Carolina, and from 1857, he operated his Albany Brewery at 71–75 Everett (now Natoma) Street, a few blocks from Wieland.

Though he would remain in a second tier to Wieland in brewing prominence, Spreckels excelled mightily with another dining table staple. An article in the May 22, 1881 issue of the *San Francisco Merchant* reported: "While running the brewery, Mr. Spreckels overheard a conversation between some of the employees of the San Francisco Sugar Refinery about the carelessness, extravagance, and extraordinarily wasteful manner in which that business was conducted."

Spreckels knew an opportunity when he saw one. He entered the sugar business in 1867, taking over the sugar refinery at Eighth and Brannan Streets, and went on to build an empire in the trade of that commodity that was second to none. He would dominate the sugar trade between Hawaii and the West Coast until his death in 1908. In the meantime, in the 1880s, Spreckels sold his brewery to Frederick Hagemann, who retained the Albany brand name under the banner of his Hagemann Brewing Company.

As the city grew, more than tripling its Gold Rush–era population to nearly 150,000 during the 1860s, the city also expanded geographically. During that period, many of the new breweries that were established were opened well beyond the original core of the city. Of particular note is the National Brewery, started in 1861 by John Glueck and Charles Hansen at Fulton and Webster Streets, near the location of the present city hall. The National Brewery started small and remained small for some time, but it would achieve a great deal of fame and success in the mid-twentieth century—as the California Brewing Association—for its well-known Acme brand.

John Glueck passed away in 1877, and his widow, Elizabeth Glueck, stepped in to take his place at the helm for several years, being one of the first women to achieve a prominent place in San Francisco brewing. In 1880,

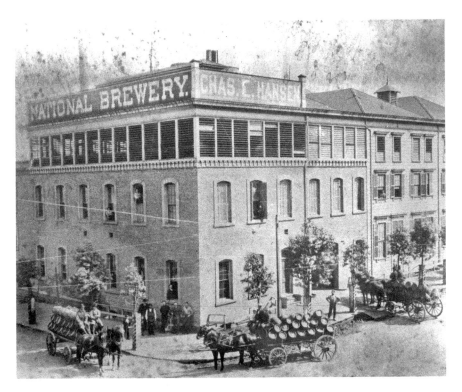

The National Brewery was established in 1861 by John Glueck and Charles Hansen at Fulton and Webster Streets. Large-scale brewing continued on this site for over a century. *Author's collection.*

however, Hansen emerged as the sole owner of the brewery. The Hansen family remained prominent in the company well into the twentieth century.

Thomas Pfether, meanwhile, had gone even farther out than Glueck and Hansen to establish his American Railroad Brewery on Valencia Street between Fifteenth and Sixteenth Streets in 1858.

In North Beach, Hermann Schwarze's San Francisco Stock Brewery opened at Powell and Francisco Streets in 1866. Others in the area now included Charles Meltzer's Golden Gate Brewery at 713 Greenwich. On the western side of Russian Hill from North Beach was Charles Brood's small Champion Brewery at 1222 Bush.

A number of breweries that are listed in some sources as opening in mid-1870s are actually mentioned in newspaper accounts as already operating in the 1860s. These include John Streuli's Swiss Brewery at 414–16 Dupont (now Grant), Hofner & Company's New York Brewery and the Lafayette Brewery at 723 Green Street.

The 1860s also saw more new breweries in the area south of Market Street, but they were farther out than those that had started a decade earlier. Weyand & Kasche's Bay Brewery at 612–16 Seventh Street, near Brannan, started in 1868 and operated as such until 1880, when it became the Milwaukee Brewery.

Samuel Marks's Marks Brewery, listed in many sources as not starting until 1878, was already in operation at 735 Tehama Street in the late 1860s, with twenty retail accounts in San Francisco and was distributing his wares across the Bay in Oakland.

The Mission Street Brewery, where the little girl had fallen to her death into a brew kettle in 1861, continued to be haunted by macabre bad luck. In 1865, Anthony Durkin, Charles Armstrong's partner in the business, lost his arm in a grisly accident while responding to a call as a volunteer fireman and sold his interest in the company. A year later, Armstrong sold a half interest to Matthew Nunan, an 1855 immigrant from Ireland's County Limerick, who had sold his grocery store at the southwest corner of Bryant and Ritch Streets to become a brewer.

In 1867, Nunan and Armstrong renamed the business the Hibernia Brewery after the classical Roman name for Ireland and moved it farther out. The new location was at 1225–67 Howard Street, near Ninth Street, just one block from where Connor Casey, Tim Sciascia and Kelly Caveney started the Cellarmaker Brewing Company 146 years later.

HAVING TOLD THE STORIES of the people and the places, we might now pause to imagine stepping up to the bar of a mid-nineteenth century San Francisco tavern. What styles of beer were being brewed in those early days by that flourishing number of San Francisco breweries?

In the breweries' advertising, ale and porter are mentioned consistently. These beer styles were, and are, produced using top fermenting ale yeast, *Saccharomyces cerevisiae*, which ferments at cool, cellar temperatures and is, therefore, ideally suited to San Francisco's coastal climate. Indeed, the weather here is similar to that of Britain, where ale and porter were the archetypical beer styles.

Lager, which had originated in and around southern Germany earlier in the nineteenth century, had become extremely popular in the eastern United States during the 1840s and remained the dominant style there. However, in the early days, it was problematic to brew lager in San Francisco because lager yeast, *Saccharomyces pastorianus*, requires temperatures that are very near freezing. Like lager's native Bavaria, cities such as New York, Philadelphia

and Milwaukee take freezing temperatures for granted, and enough ice can be harvested in the winter to be stored all year long. In the 1850s and 1860s, San Francisco had to import ice from Alaska or the High Sierra, neither of which were economical for commercial brewing.

Boca Lager was perhaps the first California lager, produced in the Sierra Nevada between 1875 and 1896 by the Boca Brewing Company in the town of the same name on the Truckee River and shipped to San Francisco.

As with so many things in a city far distant from the rest of the world, brewing innovators and entrepreneurs originated San Francisco's own unique signature beer style—steam beer. The origin of this nickname for beer brewed under primitive conditions without ice name is uncertain, but possible explanations include the picturesque sight of steam escaping into the cool San Francisco air from the rooftop fermentation vats that were standard at early San Francisco breweries. Even after the advent of artificial ice-making technology in the 1870s had made lager brewing commercially practical, San Francisco brewers continued to brew and proudly advertise their steam beer along side their ale and lager.

Another beer style that is mentioned in mid-nineteenth century San Francisco advertising is wheat beer, or to use the German term, in use then as now, *weiss* beer (aka *weissbier*), meaning "white" beer. It also was called *weizenbier*, meaning "wheat beer." Though it is less commonly cited than other styles, there was sufficient demand for *weiss* beer in the 1860s that two of the breweries we have mentioned previously came to specialize in that style exclusively. Berliner, at Powell and Chestnut, was the larger producer, brewing twenty barrels a month, selling it mainly in bottled form and "exporting" some of the products to neighboring cities. Herman Sulitz also specialized in weiss beer, but unlike the Berliner Brewery, he sold it only inside the city.

And so if we were to step up to the bar in a good San Francisco tavern, circa 1870, we would have enjoyed a selection of beer styles that would be considered respectable by today's standards. Indeed, it would have been vastly better than what we might have found—and what this author recalls finding—in 1970. The first generation of San Francisco brewers left a worthy founding legacy on which the twenty-first-century San Francisco brewers would proudly stand, but it would be a long and winding road.

2

A GROWING INDUSTRY

At the beginning of the 1870s, San Francisco was on the verge of another spurt of growth that would take its population to nearly a quarter million within a decade. This was thanks in no small part to the completion in May 1869 of the Transcontinental Railroad, which cut travel time from east to west from several months to several days.

As the 1870s began, the hierarchy of San Francisco's largest breweries had been established. John Wieland's Philadelphia Brewery was the largest with a 34,500-barrel annual output, followed by the Empire Brewery with 25,750 barrels. In a second tier, Claus Spreckels brewed around 18,000 barrels at his Albany Brewery, while the San Francisco Stock Brewery was close behind with more that 16,000 barrels annually.

Among the smaller brewers, the Washington Brewery produced 9,600 barrels, the Union Brewery made 4,200 barrels and the Broadway Brewery generated 3,600 barrels. The Hibernia Brewery and the Golden Gate Brewery each produced around 2,400 barrels a year.

In 1870, the *San Francisco Chronicle* calculated that the city's breweries each year produced the equivalent of a barrel of beer for every man, woman and child in town. The numbers apparently pleased the federal tax men. The Internal Revenue office (lowercase "o" in those days), which issued revenue stamps, naturally was meticulous in tracking the numbers. In the first eleven months of 1869, the office reported that it had collected $122,000 ($2.2 million in current dollars) from San Francisco brewers.

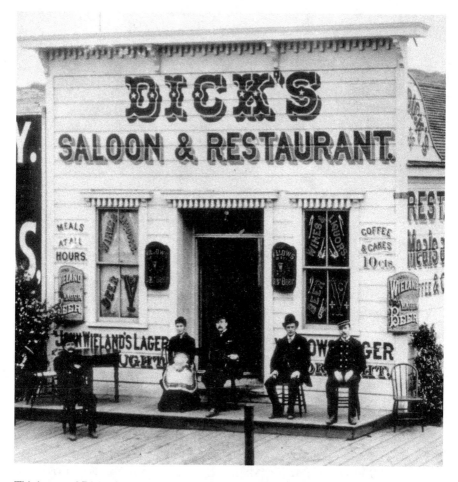

This image of Dick's Saloon on Forty-third Avenue illustrates how it was common to paint the brand names of beer served on the façades of the establishments. Dick served John Wieland's lager, as well as that of the Willows Brewery. *Author's collection.*

Nevertheless, compared to other industries, the San Francisco brewing industry was small, employing only a little more that two hundred workers in 1870. Nearly a quarter of these were employed by John Wieland at the Philadelphia Brewery. Monthly salaries generally ranged from $45 to $100, depending on specialty and seniority. The highest-paid brewmaster in town was John Mason, earlier the proprietor of the Eureka Brewery, who was now employed at the San Francisco Stock Brewery with a salary of $300. In 1874, as noted earlier, Mason moved on to start his own brewery at 527 Chestnut Street.

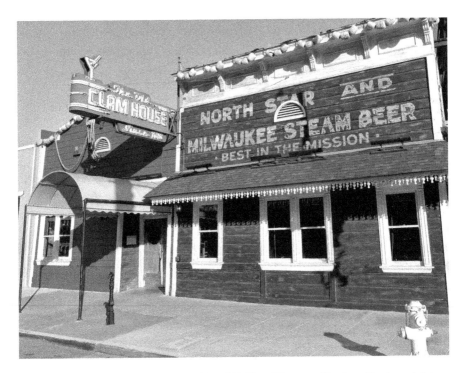

The beer advertising on the exterior of the Old Clam House on Bayshore Boulevard dates to the nineteenth century but had been covered over and was unseen until the twenty-first. *Bill Yenne photo.*

The San Francisco brewing industry annually consumed 6,750 tons of grain, all of it California-grown, and 100 tons of hops. Of these, two-thirds were sourced locally, with the rest being brought in from the East, with a small portion imported from Europe.

While most of the smaller breweries brewed only for the local market, the middle tier firms distributed widely in the Bay Area, such as to Oakland, San Jose and other places. The larger breweries exported even more widely, with sales in Oregon, Alaska and Nevada. Both the Philadelphia Brewery and the Empire Brewery shipped their beer to the Sandwich Islands, as Hawaii was then known, while the Empire also was exporting its beer to China and Japan.

Meanwhile, the excitement over the prosperity and opportunities that arrived with the Transcontinental Railroad created an atmosphere in which new businesses were cropping up and thriving. Within the San Francisco brewing community, the flurry of new brewery openings that characterized the 1860s and '70s reminds one of the dynamism of the

microbrewery scene at the end of the twentieth century. Indeed, they appear to have flourished, even in the face of the ripple effects of the Panic of 1873 that put the East into a major recession.

TWO OF THE MOST enduring elements of San Francisco brewery lore trace their roots to the 1870s. One of these is the strange and quirky Albion Castle, and the other is the original precursor to Anchor Brewing Company, the most iconic of all San Francisco brewers.

The building that now occupies San Francisco lore as the Albion Castle was originally built as the home of John Hamlin Burnell's Albion Ale and Porter Brewery, which opened in 1875. He invested generously in his

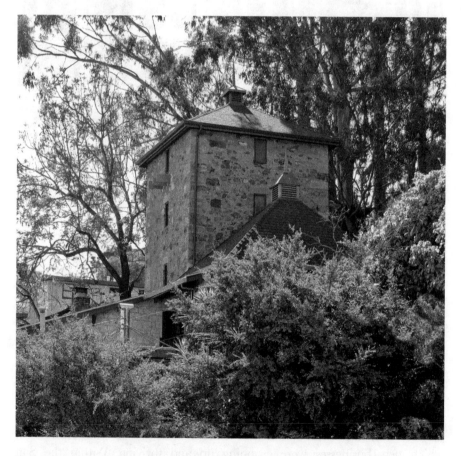

The Albion Castle, built over a natural spring on Hunter's Point in the 1870s by John Hamlin Burnell to house his Albion Brewery, still exists. His three-story central tower was constructed in the style of a Norman castle. *Bill Yenne photo.*

property, hiring masons to build his main brewery building of stone, with a three-story central tower in the style of a Norman castle, hence the appearance that gives the place its present nickname.

Because it is hard to see from the street (Innes Avenue) and is located in a part of the city far from any beaten track, the Albion Castle has an aura of mystery about it. In the 1870s, this part of town was even farther from the beaten track, and not even in town, as it was then outside the city limits on a hilly peninsula of land settled by brothers Phillip and Robert Hunter. It is still known as Hunter's Point, though the brothers themselves have faded into obscurity. Their dream of a second city of San Francisco Bay to rival San Francisco itself never materialized, but the numerous springs in the steep ridgeline of Hunter's Point provided the brothers with a lucrative opportunity. In 1855, they leased the water rights to the Independent Water Company, which supplied barreled fresh water to the city and to ships that were provisioning for ocean voyages.

Meanwhile, Burnell, a native of East Hoathly, Sussex, in England, had come to Canada to seek his fortune in the fur trade and had apparently done well for himself when he moved south to become a brewer. Though Hunter's Point was far from the center of San Francisco, the availability of good, fresh water from the springs made it an attractive location.

Burnell's vision was to brew ale and porter in the English style, and he named his brewery "Albion," the ancient name for Britain. He may have been aware that his countryman, Sir Francis Drake, had landed at Point Reyes, forty miles to the north, in 1579 (he missed the entrance to San Francisco Bay in the fog) and had claimed Northern California for the British Crown under the name "Nova Albion," or "New Albion." Burnell could not have known that in 1976, Jack McAuliffe would found the twentieth century's first American microbrewery thirty miles inland from Drake's landing and name it the New Albion Brewery.

As John Burnell proceeded to build his Norman castle to house the Albion Brewery, the stone may have been quarried nearby, but there are stories that it may also have come to San Francisco as ballast aboard sailing ships. He did quarry tunnels into the hillside for use as storage for his bottled and barreled product, and this produced a lot of stone that would have been more logically used on site than hauled away. These tunnels still remain and are part of the Albion Castle lore, though they are now partially filled with spring water. Recent estimates indicate that they are two hundred feet deep, but in the 1880s, figures given by the brewery itself were three times that.

Burnell also invested generously in his beer, importing hops and malt directly from England. In a *San Francisco Chronicle* review published on New Year's Day 1887, it was said that at the brewery, "porter equal to the Dublin stout [Guinness] and pale ales, which can not be distinguished from the English drink, are brewed, and while the imported beverages can not be delivered at a less figure than $2.50 a dozen [bottles], the [Albion] brew costs but $1.50 for the same quantity."

At the time, a wide range of imported products was easily available in San Francisco. These included stout from Guinness and ale from Bass. Based in Burton-upon-Trent in England, Bass was, at that time, the largest brewery in the world, exporting globally. Guinness was also widely available on six continents. In San Francisco, both beers were then distributed by Lebenbaum, Goldberg & Company at the corner of California and Polk Streets.

The review went on to add, "The quality of the [Albion] ale and porter has been pronounced excellent by expert tasters, who have declared their inability to distinguish them from the famous imported brands."

Through the years, the Albion Brewery provided Burnell, and later his widow, with a reasonable income. In 1919 or 1920, with her death and the impending darkness of Prohibition, the brewery closed. Albion labels dating from after Prohibition exist, but it is unclear whether the brewery actually operated after 1920. In any case, the property lay vacant until 1938, when it was purchased by the sculptor Adrien Voisin, who had once worked in East Glacier, Montana, not far from where this author grew up two decades later. During the two decades that he lived and had his studio there, he leased the water rights to the Mountain Springs Water Company, which bought the entire property in 1964. In 1973, the main building, the castle, was officially declared as a San Francisco landmark. After Mountain Springs sold it off, it went through a succession of owners, selling in 2011 for $820,000, two years after being put on the market for $2.95 million.

From one of the most obscure aspects of San Francisco brewery lore to that which is easily the most visible today, we begin the story of the Anchor Brewing Company with its earliest predecessor. In 1871, four years before John Burnell opened his castle on Hunter's Point, a German brewer named Gottlieb Brekle bought a saloon and billiard parlor at 1431 Pacific Avenue, near Hyde Street, on the slopes of Russian Hill. He soon turned it into what we would now recognize as a brewpub, though within a few years, Brekle, who had anglicized his name to "George," was operating a larger business under the name Golden City Brewery.

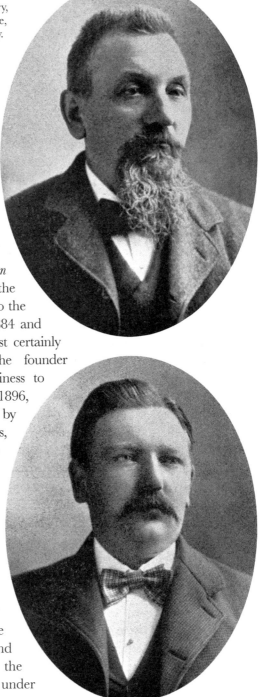

Top: In 1896, Ernst Baruth and his son-in-law bought the Golden City Brewery, founded by Gottlieb (George) Brekle, and renamed it the Anchor brewery. *Courtesy of Anchor Brewing.*

Bottom: Otto Schinkel Jr. partnered with his father-in-law, Ernst Baruth, in operating the Anchor brewery on Russian Hill. In 1907, a year after Baruth died, Schinkel was struck and killed by a streetcar. *Courtesy of Anchor Brewing.*

According to federal records referenced by Don Bull, Manfred Friedrich and Robert Gottschalk in *American Breweries*, the ownership of the Golden City Brewery passed to the estate of George Brekle in 1884 and to Fred Brekle in 1888, almost certainly indicating the death of the founder and the passing of the business to a younger generation. In 1896, the property was acquired by two other German brewers, Ernst Baruth and his son-in-law, Otto Schinkel Jr. They renamed the business the Anchor Brewing Company, presumably referencing the maritime activities that were important to San Francisco's culture and economy.

AMONG THE OTHER NEW breweries of the 1870s were several that, like Albion and Anchor, would survive into the twentieth century, albeit not under

their original ownership. The firm of Hildebrandt & Company opened the Enterprise Brewery on Folsom Street near Sixteenth Street in 1873, followed by several prominent players in 1874. These included William Frederick's Jackson Brewery, originally at 1428 Mission Street near Tenth Street; Fauss & Kleinclaus's establishment (later the Willows Brewery) at Mission and Nineteenth; and Joseph Schwartz's North Beach Brewery at 420–28 Chestnut near Powell.

The firm of Wanemacher & Kronenberg opened a brewery in 1875 at the corner of Franklin and McAllister in the Western Addition, but a year later, Frederick Kronenberg, a partner whose residence was listed as 582 McAllister, became the sole proprietor. A decade later, he had moved farther west to 311–23 Fulton Street and was doing business as the United States Brewery. There seems to be no connection with the United States Brewery that had briefly been operated by a man named John Erfelding in the late 1860s.

At 512 Grove Street near Octavia, a few blocks from Kronenberg's second location, Henry Walmuth opened his Hayes Valley Brewery in 1875. Up the hill from the establishments of Kronenberg and Walmuth, in what is now Polk Gulch, Ahrens & Company opened the Chicago Brewery at 1420–34 Pine Street near Larkin at about the same time.

An interesting footnote to San Francisco brewing is that, while Eastern and Midwestern breweries were often named after cities and regions in Germany or central Europe, breweries in the West were often were named after brewing centers in the East or Midwest. San Francisco, which had boasted two Cincinnati breweries in the 1850s, welcomed a Chicago Brewery, which joined the existing Philadelphia Brewery and New York Brewery and would soon be joined by the Milwaukee Brewery when the Bay Brewery was renamed in 1880. In many cases, the names implied the origins of their founders.

Another, more important, footnote to nineteenth-century San Francisco brewing that should not be overlooked is the fact that there existed a parallel industry of contract bottlers. Today, we have become accustomed to the general assumption that breweries that market their product in packaged form maintain bottling and/or canning lines. In the nineteenth century, however, it was more common for the majority of the product to be bottled by an outside firm.

Parenthetically, the idea of independent packaging for beer in San Francisco came full circle in 2012 with the advent of the Can Van, a mobile canning line in a truck trailer that is being taken directly to small breweries or large breweries wishing to do a short run of cans for a limited release. The Can Van was the brainchild of friends who met in the Presidio Graduate

School Sustainable MBA program. All craft beer lovers, the Can Van's contract canners include Jake Blackshear, Jenn Coyle, Kate Drane and Lindsey Herrema.

Among the independent contract bottling firms that were active during their heyday back in the second half of the nineteenth century were those of Arnold and Rudolf Postel on Dolores Street and Adolph and August Lang on Polk Street. Both the Lang brothers' partnership and the firm of Jacob Denzler had contracts with the Philadelphia Brewery, San Francisco's largest brewer.

Meanwhile, Charles Hansen's National Brewery operated a parallel National Bottling Works to bottle its own product, and apparently, National Bottling also bottled for other brewers.

Another of San Francisco's major bottlers was also a brewer, albeit not in San Francisco. The Fredericksburg Brewery, started in San Jose by Gottfried Krahenberg in 1856, became that city's largest and moved north in about 1892—but not as a brewing company. It came to San Francisco to take over the Lang brothers' firm, which was by then located at 1510–22 Ellis Street, and to rename it the Fredericksburg Bottling Company.

Meanwhile, the unsettled story of the Broadway Brewery at Broadway and Stockton—where Joseph Albrecht had bought out Jacob Specht and then partnered with Johanas Adami in 1862—continued as a tangle of intrigue. Adami died in 1868, and though there was later a rumor that Albrecht had murdered him, there seems to have been no recorded public mention of such a theory at the time.

The plot thickened as Albrecht began fudging on his tax stamps, and in 1871, the brewery was seized by federal tax collectors. Though Albrecht was able to regain control, he was clearly in trouble. In 1873, the son of Johanas Adami, who had anglicized his named to Jacob Adams, took over the Broadway Brewery in partnership with John Specht, the son of Joseph Specht, whose family still owned the building. Adams promptly took out an advertisement announcing that he would continue to brew "the best lager."

Two years later, he bought out Specht as his father had bought out Specht's father more than a decade earlier. Adams subsequently moved the business well south of the original location, and south of Market Street, to 3151–91 Nineteenth Street near Treat Avenue. Coincidentally, this was just around the corner from where Chris Lawrence opened his Southern Pacific Brewing Company in 2012.

Meanwhile, across town, tragedy, legal trouble and family strife were also brewing at the Hibernia Brewery on Howard Street. In 1870, the company, clearly a third-tier brewery in the scheme of things, found itself nearly

$30,000 in debt. One of the two partners, Charles Armstrong, driven to despondency, dramatically committed suicide in the brewery's office, leaving his wife, Joanna, and his partner, Matthew Nunan, holding the debt. Joanna was convinced to sell her share to Nunan. He did not have the cash to buy it, so he borrowed from his brother, Thomas Nunan. The nature of the transaction was apparently perceived differently by the two parties, but this would not become an issue for more than a decade.

Thomas would come to believe that the money he had advanced gave him some equity in the business. However, Matthew, who worked hands-on to turn Hibernia back to profitability, did so under the assumption that he was the sole proprietor and that the loan from Thomas had been merely that.

In the meantime, Matthew suffered the indignity of a visit from the feds. On a Saturday night in January 1879, Internal Revenue deputy collector Adams came knocking. He seized the brewery on changes that "the Revenue law had been violated by failure to cancel [tax] stamps on packages of beer." Adams also seized the owner of the Hibernia Brewery and had him locked him up pending his making a bail of $5,000. What thickened the plot was that, by this time, Matthew Nunan was serving his second term as the sheriff of the city and county of San Francisco.

Apparently, Nunan spent the night behind bars, and when he got out, he complained that it was unfair for the feds to have shut down the Hibernia Brewery. He told reporters, "It has been a common custom among all the breweries in the city for some time past to neglect canceling the stamps on their packages [and] that packages of beer with uncanceled stamps have been seized belonging to the Empire and Lafayette Breweries, yet both are still in operation."

Over the years, Nunan had returned the Hibernia Brewery to profitability, selling increasing volumes of its steam beer, so it was an attractive target for the federal agents. Nunan himself had become a modestly wealthy and was seen as *the* member of his family of six brothers to whom one could turn in times of need.

However, for one brother, there would soon be times of greed.

In 1881, Thomas finally decided to take Matthew to court to get his hands on some of the wealth. Claiming to have been a "silent partner" in the Hibernia Brewery all the while, he sued on the basis of Matthew having "overdrawn his share of the receipts of the business." Matthew insisted that Thomas had never been a partner, silent or otherwise, and that the money Thomas had paid Joanna Armstrong had been in the form of loan to Matthew.

The case dragged through the mud and through the courts for three years before finally being resolved, doing severe damage to the fabric of the Nunan family, who watched with interest and consternation. At various points, family members took the stand to testify on behalf of one brother or the other.

Superior Court judge Timothy Reardon, in his opinion, wrote, "The bitterness of this brotherly quarrel had extended through the testimony of the adherents of each until it would seem as if each and every witness had a personal stake in the contest and was straining every fact in favor of his interests. And indeed the witnesses throughout would appear to be almost all of them personally or peculiarly interested in the event of the contest, and hardly a statement made can be viewed by the court without some distrustful reserve."

Reardon ruled that Thomas was not a partner, but because he advanced the cash for Matthew to buy out the interest of an equal partner, he was entitled to half the "brewery plant." Matthew Nunan continued at the helm of the Hibernia Brewery until his death in 1916. The brewery closed in 1920, along with the last of the San Francisco breweries, and did not reopen after Prohibition.

By the 1880s, things were changing on the San Francisco brewery scene. That decade saw relatively fewer new brewery openings than there had been in previous decades, even as the total annual output for the industry was topping 350,000 barrels citywide.

Among the newcomers to the scene was the Sierra Nevada brewery, which was started in 1882 by the firm of Schneider & Wachter at 1431 Pacific, less than one block from Gottlieb Brekle's Golden City Brewery. The name obviously brings to mind the iconic Sierra Nevada Brewing that was started in Chico, California, in 1979 by Ken Grossman and Paul Camusi, a company that grew into the second-largest brewing company based in the American West—after Coors—by the turn of the twenty-first century. In 1893, the earlier Sierra Nevada in San Francisco was sold to Henry Belmer, who renamed it as the St. Louis Brewery.

Another '80s brewery of note is the Red Lion Brewery, a small operation formed in 1888 by Jacob Stuber and Albert Weikert, who brewed weiss beer at their plant at Geary and Baker Streets in the Western Addition. It apparently had no connection with the Lion Brewery that had brewed ale and porter on Pine Street between Montgomery and Kearny streets in the 1850s.

Meanwhile, there were also some important name changes. It was in 1880 that the old Bay Brewery at 612–16 Seventh Street, near Brannan,

was renamed the Milwaukee Brewery. In 1891, the Milwaukee moved to larger facilities at 432–36 Tenth Street, a place that was to be one of the most important addresses in San Francisco brewing for nearly nine decades as a succession of large and significant breweries would continue to occupy the site.

A subtle name change came during the 1880s at the Bavarian Brewery started by Jacob Gundlach and Philip Frauenholz on Vallejo Street in 1852. When the last of the founders died, his widow, Anna Maria Frauenholz, sold the business to Frederick Schultz and his son, Louis, who renamed it the Bavaria Brewery. At the turn of the century, it would become the Wunder Brewing Company.

Shortly after the start of 1885, tragedy struck the San Francisco brewing community with the violent death of its most prominent member. As explained in the *Daily Alta California* on January 3:

> *Last night a coal oil explosion occurred on Second and Tehama streets, and John Wieland, the well-known brewer, was seriously burned. A toy engine had been given to Wieland's son, Albert, aged ten years, and last night the boy asked for some coal oil to run the engine. The father went into the cellar, where he has about two hundred and fifty cases of oil stored, and was followed by his daughter Bertha, aged seventeen years, who carried a candle. Mr. Wieland held the candle while he opened a can of oil, and suddenly there was a loud explosion. Bertha and Albert were badly burned, and rushed out of the cellar. Wieland was very badly burned about the face, hands and breast, and fell to the ground. His son Herrman, aged twenty-nine years, heard the explosion, jumped into the cellar, and speedily wrapped his coat about his father's face, after which he carried him out.*

Neither the brewer nor his daughter survived. *The Bay of San Francisco* notes that "this affliction caused a deep gloom to settle over the city, and many sympathizing friends did all in human power for the bereaved and suffering family."

Wieland was remembered not only for being the industry's most dominant individual but also for such things as having been a benefactor of the Dolphin Club, a rowing and swim club based at the foot of Leavenworth Street, which still exists to this day.

In May 1887, two years after Wieland's death, the Philadelphia Brewery and the Fredericksburg Brewery in San Jose, because of their significant size, became the central focus of a strike in which the Brewers'

& Maltsters' Union demanded that all non-union employees of the major breweries be fired.

The Brewers' Association, the industry group, countered with the statement that there were plenty of non-union brewers in the city who would take the jobs. Reference was made to the breweries in Chicago and St. Louis where union and non-union workers coexisted and were paid lower wages than what was being paid in San Francisco. The Philadelphia Brewery was shut down, and a boycott of its products—from Sacramento to Australia—was initiated. In July, the Philadelphia Brewery finally capitulated, hired back the former strikers at higher wages and led the way among San Francisco breweries in unionizing its plant.

Yet another broad transformation came to the San Francisco brewing community in the 1880s, that being the specter of outside ownership. Like the great brewing industry consolidations that have been seen globally since the 1990s, this was to be a period of takeovers.

In the 1880s, against the backdrop of a widespread economic downturn in the United Kingdom, British venture capitalists were crossing the Atlantic in search of investments in various American industries. One of the industries on which they set their moneyed sights was the American brewing industry. Substantial acquisitions were made in the East, in Chicago and in Milwaukee. However, attempts to acquire Pabst and Schlitz—two of Milwaukee's, and America's, largest—failed.

The news of these activities was well known within the San Francisco brewing community, but there was a sense that the tide of acquisition would not reach Pacific shores. In June 1889, though, the front men for several British syndicates began making the rounds in San Francisco. One man in particular, a New Yorker named Julius Lesynsky, met with a number of breweries in San Francisco. He told the *San Francisco Chronicle* that, having bought several breweries in Detroit and Philadelphia over the previous months, "I am not limited as to money in making purchases of brewing properties."

When asked what he planned to do in San Francisco, Lesynsky said, "We will buy all the breweries in the city. We will then consolidate them under one management, shutting down the smaller breweries and running the large ones to their utmost capacity."

By the end of the month, it was announced that the John Wieland Brewing Company, the holding company for the Philadelphia Brewery, had agreed to sell the business, as well as the buildings and property on

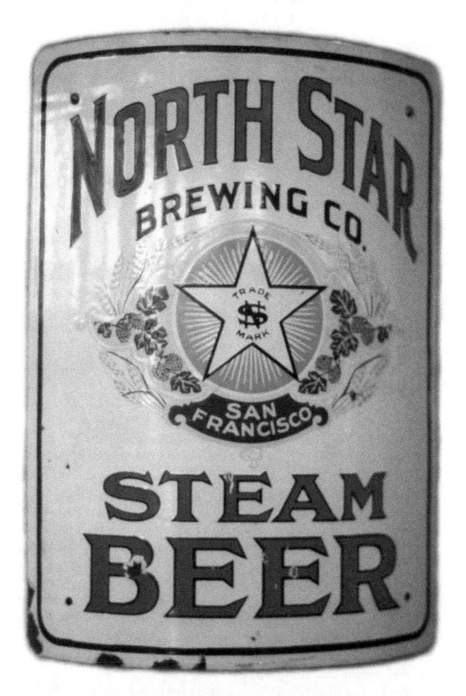

The North Star Brewing Company operated on Army Street near South Van Ness, overlooking Islais Creek, from around 1897 until Prohibition. It filed papers to reopen after repeal but faded inside a year. This curved enamel sign is on display at Anchor Brewing. *Bill Yenne photo.*

Second Street. The price was $3 million ($80 million in today's dollars), with $500,000 down.

During the coming months and into 1890, the British consolidated a number of breweries in the San Francisco Bay Area into an entity called San Francisco Breweries, Ltd. In addition to the Wieland property, those in the city included the United States Brewery, the Chicago Brewery and the Willows Brewery. Other acquisitions included the Oakland Brewery and Brooklyn Brewery in Oakland and the Hofburg Brewery in Berkeley. In San Jose, the syndicate took over the Fredericksburg Brewery and the Pacific Brewery.

In the San Francisco Breweries, Ltd. Prospectus, published in May 1890, the property was valued at $5 million (around $130 million in today's dollars), including $1.6 million for real estate alone and the remainder for buildings and equipment. The man who had been charged with doing the valuation was John Mason, who had been one of San Francisco's pioneer brewers and whose name had been associated with several breweries of a career that spanned four decades.

In contrast to the consolidation that occupied the larger breweries, there were still a few new breweries coming on line. Among those that made their appearance in the 1890s were the California Brewery at 111–23 Douglass Street near Seventeenth in Eureka Valley and the North Star Brewing Company on the banks of Islais Creek at 3310–14 Army Street. Old records cited by Don Bull and his colleagues in *American Breweries* show the closing of the Union Brewery on Clementina Street in 1896 and the opening that same year of a Union Brewing Company at Florida and Eighteenth Streets near Harrison Street. The Eagle Brewery opened at 2015 Folsom, and by 1899, proprietor Carl Törnberg had moved a short distance to 2213–29 Harrison Street.

As the people of the San Francisco brewing community bade farewell to one century and greeted another, two disasters, one natural and one a contrivance of human naiveté, awaited them.

3

INTO A NEW CENTURY

The twentieth century began against the backdrop of two contradictory trends in American brewing. On one hand, the output of the brewing industry was up dramatically. Nationally, total volume was increasing, up from only nine million barrels in 1873 to fifty-three million barrels in 1910.

During those same years, however, there was a growing temperance movement in North America and around the world. What began as a reaction to excessive public drunkenness evolved into a militant opposition to the sale and consumption of all alcoholic beverages. Brewers had responded by positioning beer as a beverage of "moderation" when compared to spirits, but gradually, beer also found its place on the hit list of organizations such as the violent and venomous Anti-Saloon League. By the second decade of the century, the momentum of the temperance movement became unstoppable. Though few in the industry believed in 1910 that it would come to this, the dark cloud of Prohibition would descend on the whole nation a decade later.

In the meantime, though, the San Francisco Bay area met with an enormous and very sudden natural catastrophe—not an earthquake, but *the* Earthquake, always spelled with a capital "E." At dawn on April 18, 1906, the ground rumbled with a powerful temblor whose magnitude has been estimated at various points on the Richter scale from 7.8 to 8.3.

The damage to San Francisco that morning, which was considerable, paled in comparison to that of the firestorm that ensued over the coming days. The fire destroyed the heart of the city, from San Francisco Bay westward to

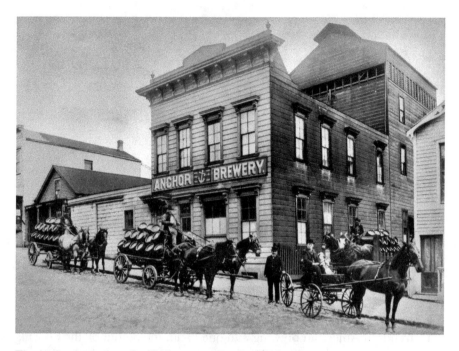

The Anchor brewery on Pacific Avenue on Russian Hill in 1906, shortly before it was destroyed by the fire that ensued after the Earthquake. The company survived but moved south of Market Street. *Courtesy of Anchor Brewing.*

Van Ness Avenue and south to Townsend Street, with a narrow tongue of destruction between Dolores and Howard as far south as Twentieth Street. Virtually all of San Francisco's brewing companies were within this area, and their owners and employees found themselves pondering devastation and uncertainty. Indeed, many had lost their homes as well as their livelihoods. The *Western Brewer*, the industry trade journal, reported in May 1906 that the only breweries to survive destruction were Albion, Broadway, Eagle, Enterprise, North Star, Union and the Wunder (formerly Bavaria) Brewing Company. Also on the survival list was the Consumers Brewing & Bottling Company, barely a year old, which was owned by Carl Törnberg of the Eagle Brewery.

All of the San Francisco Breweries, Ltd. properties, Chicago, Wieland, Willows and the United States Brewery, were knocked off line, as were major producers such as the Milwaukee Brewery, the Hibernia Brewery and Hagemann's Albany Brewery.

The Anchor brewery was among the smaller operations that were destroyed. Today, the company still refers to 1906 as "an uncanny year

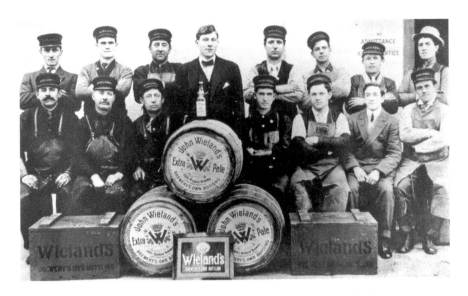

Employees of the John Wieland Brewery. After his death, his Philadelphia Brewery was renamed for him. It entered the twentieth century as part of San Francisco Breweries, Ltd. *Author's collection.*

of misfortune" because a trifecta of disasters befell it. This began in February, two months prior to the Earthquake, when co-owner Ernst Baruth died suddenly. Then, in April, as the great fire swept over Russian Hill, it destroyed virtually everything in its path, including the brewery. In January 1907, as the company was opening at a new location south of Market Street, Baruth's partner and son-in-law, Otto Schinkel, was struck and killed by a streetcar. However, brewers Joseph Kraus and August Meyer, together with a liquor store owner named Henry Tietjen, managed to pull the company though the last of the three disasters of its uncanny year of calamity.

Despite the unimaginable devastation, San Francisco and its brewing community bounced back quickly. The city that had built itself into a world-class metropolis two thousand miles from civilization half a century earlier rebuilt itself in record time, with more than fourteen thousand building permits issued within two years.

Five years after the Earthquake, the San Francisco brewing scene, with its new member from the Northwest, was getting back to the old normal. The *United States Brewers' Association Year Book* published a checklist of the breweries then operating in San Francisco. Heading the list were the four San Francisco Breweries, Ltd. properties in the city, as well as the Brooklyn

51

Brewery in Oakland and the Fredericksburg Brewery in San Jose, that had been briefly out of action because of the Earthquake.

The rest of the list for San Francisco included the Anchor brewery, the Broadway Brewery, the California Brewery, the Eagle Brewery, the Enterprise Brewery, Hagemann's Albany Brewery, the Hibernia Brewery, the Jackson Brewery, the Milwaukee Brewery, the National Brewery, the North Star brewery, the St. Louis Brewery, Union Brewing & Malting and the Claus Wreden/Washington Brewery. The Golden West Brewing Company on Kirkham Street was also listed for San Francisco, but it was actually on the street of that name in Oakland. Notably absent were the Albion Brewery and Wunder Brewing Company. Carl Törnberg of the Eagle, meanwhile, was mentioned in post-earthquake Scandinavian community newspapers as being a distributor and importer of such products as Carlstens Porter and Svensk Punsch, as well as for his own Törnberg's steam beer.

There was also a new name on the list, one that was to become the biggest name in San Francisco brewing later in the century. That name was Acme.

It is worth pointing out that this came about because the major brewing companies of the Pacific Northwest took the specter of Prohibition a lot more seriously than their counterparts in the Golden State.

In April 1907, one year after the Earthquake, the *San Francisco Call* reported in a tiny, one-column article:

> *The Olympia brewery interests, engaged in the manufacture of beer in Oregon and Washington, are going to invade the San Francisco field with a brewery, under the name of the Acme Brewing Company, which was Incorporated yesterday with a capital stock of $100,000 by Leopold F. Schmidt of Olympia, Wash., and William Schuldt and Jacob P. Rittenmayer of San Francisco. Schmidt is president of the Olympia Brewery and it is announced that the new company will soon construct a plant at Sansome and Green streets.*

Schmidt had been "exporting" his Olympia lager into California through local distributors since 1902, and he had made a great deal of money satisfying San Francisco demand while the local breweries were down after the Earthquake. Now, he was ready to make his move, landing his "invasion" in a big brick building on Sansome Street at the foot of the eastern slope of Telegraph Hill.

As the Acme project was ramping up, Schmidt was facing trouble on his home turf because of the tide of the temperance movement. While

his flagship Olympia Brewery was in Tumwater, a suburb of Olympia, Washington, he also owned several other breweries from Bellingham, Washington, to Salem, Oregon, so he had a lot invested in the Northwest, where there was a growing clamor for total prohibition. In many parts of the country, states were voting in statewide prohibition. Several states on the Great Plains had been dry since the 1880s, and a swath of southern states followed suit in 1908–9. Schmidt was thankful that he had read the writing on the wall when the misguided electorate in both Oregon and Washington voted in 1914 to become dry states, effective on the first day of 1916.

Schmidt was not alone among his fellow Northwest brewers in taking preemptive measures on the eve of Prohibition. San Francisco welcomed two other well-heeled refugees. The first was Pacific Brewing & Malting of Tacoma, Washington, which originated as the Puget Sound Brewery, started in 1888 by Anton Huth and John Scholl.

The other Northwest refugee was Seattle Brewing & Malting, which had originated as the Bay View Brewing Company, a small brewery started in the Emerald City in 1883 by Andrew Hemrich and John Kopp. Within a decade, it had absorbed several other Seattle breweries and had become Seattle's largest brewer—and probably the largest brewing company in the Northwest—under the leadership of Andrew's brother, Louis Hemrich. Its flagship brewery was the largest brewing plant west of St. Louis. Though the company was renamed Seattle Brewing & Malting in 1892, the company was best known by its widely distributed flagship brand, Rainier, the namesake of which was the fourteen-thousand-foot snow-capped volcano that is visible from Seattle.

In 1915, when it became clear that Prohibition was coming to Washington, Carlton Huth and Louis Hemrich came south. The former built a plant at 675–77 Treat Avenue near Nineteenth Street in San Francisco—across the street from the machine shop at 620 Treat where Chris Lawrence would open the Southern Pacific Brewing Company in 2012. Hemrich, meanwhile, formed Rainier Brewing Companies in both British Columbia and San Francisco. At 1550 Bryant Street near Fifteenth in San Francisco, Hemrich built the largest brewing facility in California, completing the project in only six months.

Like Leopold Schmidt, both Carlton Huth and Louis Hemrich hade wagered substantially against the adoption of nationwide Prohibition—and lost. California, with its powerful wine industry, seemed immune to the Prohibition frenzy, and the beverage industries had acted accordingly. However, they, too, were destined to be proven wrong.

In 1916, because of—or in spite of—the arrival of Prohibition in the Northwest, the San Francisco brewing industry undertook the biggest industry consolidation since the British had come to town in 1889. Six brewing companies agreed to consolidate into a cooperative to pool resources, and in January 1917, the California Brewing Association was formed.

They were not alone in this idea. During the first few years of the new century, eighty-six breweries in Massachusetts, Maryland and western Pennsylvania merged and were replaced by just a half dozen brewing companies. The new California Brewing Association included five from San Francisco and one from Oregon. As listed in the *San Francisco Call*, they were the Acme Brewing Company, the Broadway Brewery, the Claus Wreden (Washington) Brewing Company, the National Brewing Company and Union Brewing & Malting. The sixth was the Henry Weinhard Brewery—later a regional icon—in Portland, Oregon. In San Francisco, under the California Brewing Association, all of the actual brewing plants were closed, except that of National at Fulton and Webster Streets and the new Acme facility.

By 1917, however, the momentum of the temperance movement had reached the point of being unstoppable. Prohibition had become a national political issue, driven by anger and bigotry that was pointedly directed at recent immigrants. Because beer and wine were associated with immigrant cultures, especially the Germans, Irish and Italians, many nativists joined the temperance movement out of a belief that alcohol was an indulgence of inferior races. One would have liked to have called on distiller George Washington and brewer Thomas Jefferson to rebut this notion.

Because of World War I, which began in Europe in 1914 and swept up the United States in 1917, there was a great deal of anti-German sentiment in the United States. The prohibitionists were able to seize on this and use it against the owners and employees of breweries, most of whom were German. By the time a constitutional amendment to prohibit the manufacture and sale of alcoholic beverages in the United States had passed Congress at the end of 1917, two dozen states had already gone dry. Ratified as the Eighteenth Amendment, Prohibition became law in January 1920. It was enforced by the draconian Volstead Act of 1919. Under Prohibition, it became illegal to manufacture, transport or sell alcoholic beverages in the United States.

Prohibition was like an earthquake that decimated both an industry and those who depended on it. Breweries and wineries, of which there were many in and near San Francisco, places that had been legitimate family businesses one day became empty shells or outlaw enterprises the next.

Throughout the United States, 1920 was the end of the line for the majority of the legitimate brewing companies. The few who did not shut their doors forever turned to manufacturing other things, from malted grain products to barely alcoholic "near beer."

In San Francisco, the California Brewing Association reemerged as the California Bottling Association, producing ginger ale and near beer under a variety of brands, including Acme and Old Bohemian. The company also formed the Cereal Products Refining Corporation, which marketed various brands of malt syrup, yeast, vinegar and even ice cream.

Now regarded as one of the worst legislative disasters in United States history, Prohibition was undertaken with respectable intentions and was even described at the time as the "Noble Experiment." Instead, it was an ignoble disaster. While legitimate businesses suffered, illegal production was rampant. With alcoholic beverages banned, their manufacture became a growth industry for gangsters. It did not take long for it to become obvious that Prohibition was a disaster, but it took all of the Roaring Twenties, and then some, to end it.

In the 1932 presidential campaign, a plank in Franklin D. Roosevelt's platform called for repeal. He won by a landslide. Within a month of his inauguration in March 1933, he signed "emergency" legislation legalizing beer with up to 3.2 percent ABV. Though repeal was not fully implemented through the Twenty-first Amendment until December 1933, Roosevelt "got the beer flowing" in most states in April.

After repeal, the industry struggled to regain its feet. The major companies that had stayed afloat with near beer and other products were able to resume brewing within a short time, but smaller businesses found resumption to be a great deal more difficult. Many of the small-town breweries that had folded stayed folded. Of the 1,568 breweries that had existed across the United States in 1920, only 756 would reopen, but because of the weight of expenses incurred in reopening, many of these would fail during the first year after repeal. In turn, the majority of the survivors would cease to exist during the ensuing Great Depression.

To walk the streets of San Francisco in 1933, attempting to revisit the once vibrant brewing scene that one might have remembered from the turn of the century, one would have had an experience virtually unrecognizable from that of the days before the Earthquake.

Of the properties that had been optimistically folded into San Francisco Breweries, Ltd. back in 1890—and which had risen from the ashes of 1906—none of those in San Francisco remained. The only brewery from

The Albion Brewery closed in 1919 or 1920 and is not known to have reopened. This label for Albion beer dates from after Prohibition, but it is not clear whether the beer was actually brewed or whether the labels were printed in anticipation of a reopening that never happened. *Courtesy of the Meyer family collection.*

that conglomerate to return was the Fredericksburg Brewery in San Jose, which had been shuttered through Prohibition and was reopened under the ownership of Pacific Brewing & Malting. The great John Wieland Brewery in San Francisco was marked for reopening and the paperwork had been filed, but it never happened. Beer bearing the Wieland brand name was, however, produced at the plant in San Jose. In San Francisco, the Pacific Brewing & Malting plant on Treat Avenue reopened as the Regal-Amber

India pale ale originated in England in the early nineteenth century, died out as a style and was rediscovered by craft brewers late in the twentieth century—or so we're told. However, Regal was brewing its version of IPA in the 1940s. *Courtesy of the Meyer family collection.*

Brewing Company and was renamed Regal Pale in 1954. The Regal brand products continued to be produced until the 1960s.

One of the prominent former breweries that did resume operation was the great Milwaukee Brewery, with its huge and upgraded property on Tenth Street. It now reopened as the San Francisco Brewing Corporation. The house brands included Burgermeister and many Alpen Glow products, including ginger ale as well as beer. The San Francisco Brewing Corporation is also recalled for the numerous smaller brands that flowed across the Tenth

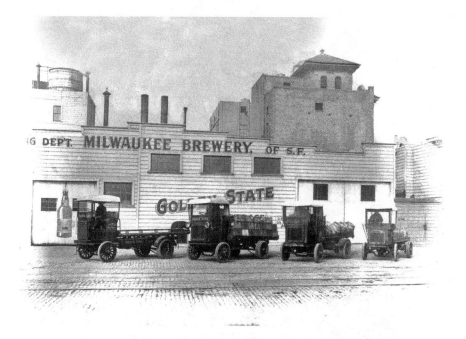

As the twentieth century began, the new facility of the Milwaukee Brewery on Tenth Street was one of San Francisco's largest. Under other names, it would remain an important fixture in San Francisco brewing until late in the century. *Author's collection.*

Street loading dock. A look through the troves of breweriana collectors turns up a number of other ale and lager brands that were brewed by the corporation from the mid-1930s into the '40s and '50s. These included Brau Haus, Casa Blanca, Dutch Toast, Golden State, Kanner's, King's Taste, Leidig's, Monterey, Pilsengold, Ramona, Red Lion, Silver Moon, Steinbrau, Tornberg's, Tru Bru, Viuda Alegre (Merry Widow) and Wilshire Club. The company also operated under the corporate names of several defunct San Francisco breweries such as Hibernia and Willows, brewing their brands until the 1950s.

Among San Francisco's smaller breweries, the old Eagle Brewery reopened on Mission Street as the El Rey Brewing Company—the first of several renamings—but it lasted for only a decade. The city that once boasted a rich tapestry of small breweries would thereafter be devoid of small breweries for more than half a century—with one exception.

Joseph Kraus, one of the men who had helped save the tiny Anchor Brewing Company from extinction in 1907, reopened the business in 1933 only to experience a major fire in 1934. Tenaciously determined, he and a new partner, Joe Allen, reopened at 398 Kansas Street and

defied the odds by staying in business through the Great Depression and beyond.

Louis Hemrich of Rainier, who had bet against national Prohibition in 1915—by building California's largest brewery—and lost had then turned to betting on repeal. This time, he won.

In 1925, he bought out the Pacific Brewing & Malting interests in San Francisco. He next invested substantially in upgrading his Rainier Brewery on Bryant Street during 1932, staking his family's money on Roosevelt's promise of legalizing beer as soon as he was inaugurated. When beer became legal in April 1933, the fires beneath the brew kettles on Bryant Street inside were already burning.

Hemrich, however, did not linger long in the business. He cashed out, selling his Seattle and San Francisco breweries to the father and son team of Fritz and Emil Sick, who were in the process of building an international chain of breweries. German-born Fritz Sick, a trained coppersmith, immigrated to America in 1883 at the age of twenty-four. He found employment in the brewing trade, where there was a high demand for copper work. Eventually, he moved to western Canada, establishing small breweries at Fernie and Trail in the mining country of British Columbia. In 1901, he started the Lethbridge Brewing & Malting Company in Lethbridge, Alberta. By this time, the dark specter of Prohibition was looming on the horizon in both Canada and the United States.

In Canada, the cruel experiment would arrive earlier but last a shorter time. Prohibition had been adopted in Canada before 1920 but had ended in the western provinces by 1925. In Alberta, it went into effect in 1916, but it lasted only until 1923. By 1930, Fritz Sick had expanded his brewing empire with the acquisition of breweries in Regina, Saskatchewan; Edmonton, Alberta; and Vancouver, British Columbia. By the time Prohibition finally ended in the United States, Fritz had turned the reins of the family business over to Emil. Emil's first of many acquisitions south of the border was to buy Seattle Brewing & Malting from Hemrich even before he had resumed production of beer. The Rainier brand name was proudly re-launched, although the Sicks would not acquire full rights to the brand until 1940. In 1935, without having actually started brewing at the Seattle Brewing & Malting site, they acquired Century Brewing, which was started on Seattle's Airport Way in 1933 and became the flagship of the Sick empire in Seattle. That empire now also included the Rainier Brewing Company in San Francisco.

Now that beer was legal again in Washington, Rainier no longer needed the huge Bryant Street plant as its corporate flagship, but it remained an

important avenue of access to the rapidly growing California market. An interesting parallel note to Emil Sick's career was his interest in Pacific Coast League baseball. Until the late 1950s, there were neither American nor National League teams on the West Coast, but the Pacific Coast League was by no means a lesser form of major-league baseball. Indeed, many of the Pacific Coast League players were paid as well or better than the "eastern" leagues. Sick bought the Seattle Indians baseball franchise at the end of 1937. By the time the first pitch was thrown in the 1938 season, they were the Seattle Rainiers, although they would generally be known as "the Suds" after the sponsoring beer. Sick also built them a new ballpark and named it Sicks' Seattle Stadium. In San Francisco, his Rainier Brewery was directly across the street and towering above the ballpark that was the home of the San Francisco Seals. To stay with the notion of the importance of the Pacific Coast League for just a moment, we might mention that the Seals were the only professional baseball team to have had not one, not two, but three DiMaggio brothers on their roster. The brothers were native San Franciscans.

The California Brewing Association, San Francisco's first brewery conglomerate since the British syndicates came to town, which had survived Prohibition with its other products, easily swung back into brewing. However, the Sansome Street plant was closed, and production was consolidated at the old National Brewery site at Fulton and Webster Streets. The Acme brand was back on the shelves in April 1934 and on its way toward becoming the leading brand in the Golden State.

This, and the scale of the other major breweries in town, set the stage for the next chapter in the story of San Francisco brewing in which the big got bigger and then very big.

4

THE RISE OF THE REGIONALS

When the Rip Van Winkle that was the American brewing industry awoke in 1933 from its decade of darkness, it came to life in a very different world in terms of communication, transportation and industrial efficiency. It was an environment very unlike that of the late teens, and one that favored the ascendancy of larger and more expansive regional, and even national, enterprises rather than those content with a small, local base.

As the number of brewing companies declined in the early years after repeal because of the cost of rebuilding and reopening, demand was increasing. As the small fry failed, the larger companies grew larger. Nationwide, the industry brewed 37.7 million barrels in 1934, surpassing 1919 by 10.0 million. The following year, the number was up to 45.2 million. This post-repeal beer was being produced by fewer than half the number of brewing companies.

In the Midwest, giants such as Pabst and Schlitz in Milwaukee and Anheuser-Busch in St. Louis came to dominate the entire middle of the country and had formed the infrastructure that allowed them to emerge with national brands. In the New York metropolitan area, brands such as Rheingold, Schaefer and Knickerbocker eclipsed many smaller brands and breweries to dominate their region.

Out west, on Tenth Street in San Francisco, the San Francisco Brewing Corporation invested heavily in promoting its Burgermeister brand, eventually embracing the abbreviation "Burgie" that was coined by consumers. Great volumes of Burgie point-of-sale materials were

In 1956, the San Francisco Brewing Corporation rebranded itself after its flagship brand as the Burgermeister Brewing Corporation and expanded the capacity of its big plant on Tenth Street to 900,000 barrels annually. *Author's collection.*

In the early 1960s, Burgermeister had become "Burgie," and it was being touted as "refreshing." *Author's collection.*

produced, and they are still commonly seen wherever breweriana is being sold or traded. In 1956, the corporate name was changed to the Burgermeister Brewing Company.

Among the great San Francisco brands that became prominent across California in the mid-twentieth century, one of the first that comes to mind is the Acme label of the California Brewing Corporation. Having brewed Acme near beer during Prohibition, the California Brewing Association started brewing real Acme again at Fulton Street in 1933 while its Sansome Street plant was reopened as the Globe Brewing Company. The latter survived only five years, even as Acme burgeoned into a California legend.

Right: While Acme's lager was the California Brewing Association's flagship and mid-century consumer tastes had migrated to more lightly flavored beers, Acme continued to brew ale for those who remembered the variety of more robust beers available earlier in the century. *Courtesy of the Meyer family collection.*

Below: Pilsengold was one of more than a dozen brand names produced by the San Francisco Brewing Corporation. The phrase "Internal Revenue Tax Paid" was required to appear on all beer labels and beer cans from June 1935 through March 1950. *Courtesy of the Meyer family collection.*

Acme struck a chord with consumers, and sales mushroomed. Much of this was in Southern California, so the company responded by constructing a new brewery at 2080 East Forty-ninth Street in Los Angeles. Opening for business in 1935, the Southern California operation formally did business as the Acme Brewing Company, while the San Francisco activity was officially known as Acme Breweries until 1943, when the California Brewing Association name was readopted. The Acme brand name continued to be used on the products brewed at both locations.

Meanwhile, an important sister company had emerged as the key to Acme's success. The Bohemian Distributing Company was based on a partnership formed in June 1921 between an energetic young beverage salesman named Frank Vitale and J.S. Foto, who operated a small retail beverage store in Los Angeles. A year later, the two partners purchased fifty cases of Acme near beer, and this initial transaction evolved into an association with the two Acme breweries that was the key to the brand becoming the de facto "national beer" of California. Indeed, the Bohemian Distributing Company was the tail that would wag the Acme dog throughout the decades of the brand's rise to renown.

In addition to the San Francisco and Los Angeles distribution centers, Foto and Vitale opened branches in Burbank, Long Beach, San Bernardino, San Diego and Santa Monica—as well as at Bakersfield in California's great Central Valley. Having solidified the California market for Acme during the 1930s, Bohemian expanded its distribution into southern Nevada, Arizona, New Mexico and even western Texas. It operated six branches in Southern California alone.

In February 1940, Bohemian opened an office and warehouse building immediately adjoining the Acme plant in Los Angeles. The combined plants would comprise five acres. By the 1940s, Southern California had clearly become the center of gravity for the Acme brand. Karl F. Schuster, the Acme president, remained in San Francisco, but in Los Angeles, J.S. Foto and Frank Vitale ran operations for both companies. In addition to being Bohemian's president, Foto was Acme's vice-president, while Frank Vitale served as treasurer for both Los Angeles operations.

When the United States entered World War II, Acme became a leading supplier of beer to troops operating in the Pacific Theater. For the home market, Acme encouraged sales of its "Victory Size" quart bottles with the slogan "Do Your Part—Buy The Quart." The idea was that packaging beer in the larger container would conserve the metal necessary for caps, and metal was vital to the war effort.

Regal was part of the portfolio of the Regal-Amber Brewing Company, which operated at the facility built in 1916 by Pacific Brewing & Malting of Tacoma, which had come to San Francisco to escape Prohibition in Washington. *Courtesy of the Meyer family collection.*

The National brand name references the origin of the California Brewing Association as the National Brewery. It was greatly overshadowed by the Acme brand, the company's flagship. *Author's collection.*

Above: The intricately detailed illustration on the Acme label pictured traditional German beer garden scenes. This specific label is from Prohibition-era near beer (called "Light" beer), but the same illustration was used on the labels for Acme "real" beer before Prohibition and for many years thereafter. *Author's collection.*

Left: Burgermeister was the flagship brand of the San Francisco Brewing Corporation, which had been the Milwaukee Brewery in the nineteenth and early twentieth centuries. It later became the Burgermeister Brewing Corporation. *Courtesy of the Meyer family collection.*

Right: A rare, uncut label for Rainier Old Stock Ale. That beer was brewed in San Francisco before and after Prohibition. Rainier's plant on Bryant Street was once the largest in the city. *Courtesy of the Meyer family collection.*

Below: A colorful label for Viuda Alegre (Merry Widow), one of the many brands produced on Tenth Street during the mid-twentieth century by the California Brewing Corporation. *Author's collection.*

Sampling Acme lager at the big brewery at Fulton and Webster in a scene from the film *What's Brewing?* (circa 1943). *Author's collection.*

Adding hops to the brew kettle at the Acme brewery in a scene from the 1940s industrial film *What's Brewing? Author's collection.*

Right: The Anchor Brewing Company facility on Mariposa Street is the largest and best-known brewery in San Francisco. *Bill Yenne photo.*

Below: Fritz Maytag developed a fondness for Anchor Steam Beer and saved the brewery from certain demise. He refined the product, transformed the brewery and wound up inspiring the craft brewing revolution. *Photo by Terry McCarthy; courtesy of Anchor Brewing.*

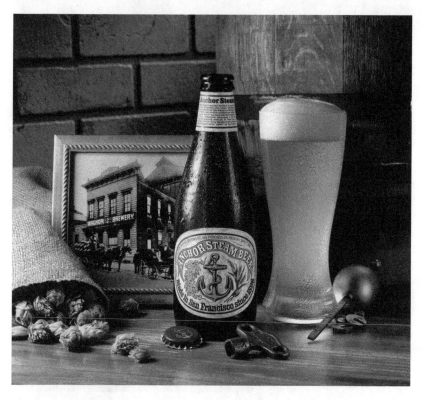

Anchor Steam Beer, the flagship product of San Francisco's oldest brewery, is the best-known and longest-brewed beer in San Francisco history. It is also generally recognized as America's first craft beer. *Courtesy of Anchor Brewing*

Mark Carpenter, who was with Fritz Maytag almost from the beginning, stayed on as Anchor Brewing's brewmaster under Anchor's new owners, Keith Greggor and Tony Foglio, when they took over in 2010. *Courtesy of Anchor Brewing*

ANCHOR BREWING CO.
SAN FRANCISCO, CA
12 FL. OZ.
BEER WITH NATURAL FLAVOR

NINKASI

SUMERIAN BEER

An attempt to emulate man's first beer brewed 5,000+ years ago in ancient Mesopotamia. We consulted written recipes and documents including the Sumerian "Hymn to Ninkasi" circa 1800 B.C. Our brewers baked over 1,000 loaves of "Bappir" bread using malted and unmalted barley, roasted barley, and honey. We added the loaves to a mash of malted barley and dates. Fermentation was normal at slightly elevated temperatures. For further information telephone 415-863-8350.

10

ESSAY, AUG. 1989

In 1989, Fritz Maytag decided to brew a beer based on a 3,800-year-old Sumerian recipe for beer. He named it Ninkasi, after the Sumerian goddess of beer. *Courtesy of Anchor Brewing.*

Allan Paul at the brew kettle in his San Francisco Brewing Company at the corner of Columbus and Pacific Avenues, circa 2002. His business was San Francisco's first brewpub and the first new commercial brewing company in the city in over half a century. *Bill Yenne photo.*

Above: Liberty Ale was first brewed by Anchor on April 18, 1975, thereby celebrating the bicentennial of "the midnight ride of Paul Revere." The 1983 Christmas ale became the second and current version of Liberty Ale, which, for many years, was second only to steam beer in popularity among the beers within Anchor's portfolio. *Courtesy of Anchor Brewing.*

Left: The label for the Seacliff brewery's Dutch Brown Ale featured a 1988 painting by owner and brewmaster Klaus Lange himself. *Author's collection.*

Ron Silberstein in the cellar of the ThirstyBear Brewing Company, the brewery-restaurant that he opened on Howard Street in 1996. A century younger than Anchor, it is San Francisco's second-oldest brewery. *Bill Yenne photo.*

The ThirstyBear Brewing Company is named for a bear that stole the beer out of the hand of a Ukrainian man named Victor Kozlov. *Bill Yenne photo.*

ThirstyBear's brewmaster,
Brenden Dobel, surveys the
fermenting room from the deck
of his brewhouse. *Bill Yenne photo.*

Steve Taormina and Todd
Siemers enjoy their pints at Dave
Keene's Toronado, the pub
that had been San Francisco's
quintessential beer bar for more
than a quarter of a century. No
bar has had more tap handles
atop kegs of a wider array
of San Francisco beers than
Toronado. *Bill Yenne photo.*

Speakeasy Ales & Lagers on Evans Avenue, San Francisco's second-largest production brewery, celebrates its eighteenth anniversary with a party in its parking lot. *Courtesy of Speakeasy.*

The so-called Usual Suspects, the year-round selections from Speakeasy Ales & Lagers, include Metropolis Lager, Big Daddy IPA, Prohibition Ale and Tallulah Extra Pale. *Courtesy of Speakeasy.*

In the taproom at Speakeasy the author met with Brian Stechschulte, the public relations and media director, and Kushal Hall, the director of brewing operations. *Bill Yenne photo.*

The Session 47 Series beers from Speakeasy are "a lineup of easy drinking beers" all under 5 percent ABV. They were the first Speakeasy products to be available in cans. *Courtesy of Speakeasy.*

The remarkable array of choices behind the tap handles at Dave McLean's Smokestack. *Bill Yenne photo.*

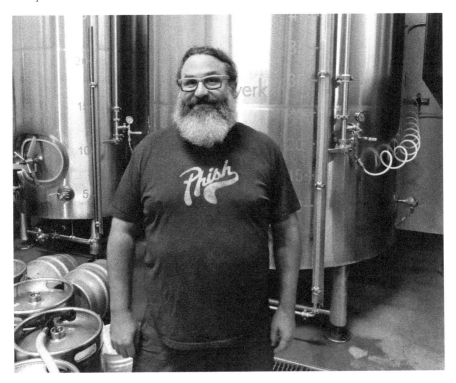

Dave McLean, the founder of the Magnolia Gastropub and Brewery on Haight Street and Smokestack on Third Street, is seen here with the custom-made Craftwerk Brewing Systems fermenters at his production brewery, which is located behind Smokestack. *Bill Yenne photo.*

The 21st Amendment Brewery was founded by Nico Freccia and Shaun O'Sullivan at the start of the twenty-first century on Second Street, only three blocks from where John Wieland's Philadelphia Brewery reigned as San Francisco's largest for much of the nineteenth century. *Bill Yenne photo.*

Popular beers from the 21st Amendment Brewery portfolio include Back in Black black IPA, Brew Free or Die IPA and Fireside Chat Winter Spiced Ale. *21st Amendment.*

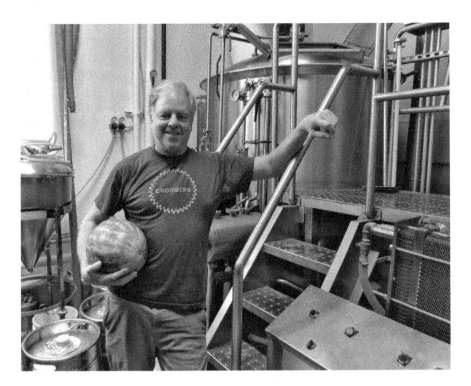

Above: Shaun O'Sullivan is seen here at the 21ˢᵗ Amendment Brewery on Second Street with one of the ingredients for his Hell or High Watermelon Wheat Beer. *Bill Yenne photo.*

Right: The picture on the Hell or High Watermelon can from the 21ˢᵗ Amendment Brewery shows Lady Liberty hanging out at the Golden Gate Bridge. *21ˢᵗ Amendment.*

The Beach Chalet Brewery and Restaurant is located directly across the Great Highway from the Pacific Ocean. Behind is the sister restaurant, the Park Chalet, which faces into Golden Gate Park. *Bill Yenne photo.*

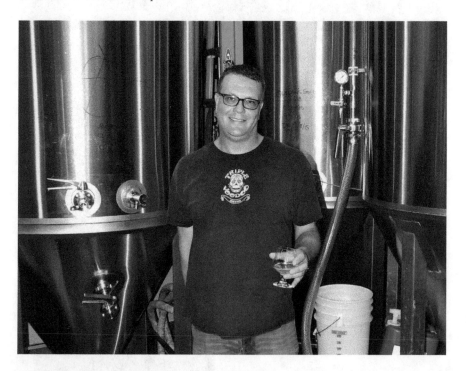

Greg Kitchen, the brewmaster at the Triple Voodoo Brewery on Third Street, samples a glass of Inception Belgian Style Ale while surrounded by his Portland Kettle Works fermenters. *Bill Yenne photo.*

Lucille Knutson tips her hat across the street from the gleaming glass brick façade of the new Acme brewery building in San Francisco. When it opened in 1942, architects described it as "one of the world's most beautiful industrial buildings." Two decades later, it was torn down to build a freeway. *Author's collection.*

To meet wartime demand, both breweries underwent major upgrades. The new Acme brewery in Los Angeles was dedicated in June 1943. In the meantime, in San Francisco, Acme's expansion plans included construction of a new brewing plant that opened in 1942 near the site of the old National Brewery. Architects described this new edifice as "one of the world's most beautiful industrial buildings."

The building was designed by architect William G. Merchant. Born in Healdsburg, in California's Napa County, he lived most of his life in San Francisco. Licensed in 1920, he worked in the office of the legendary Bernard Maybeck, where he had served as assistant designer of the Palace of Fine Arts at the Panama-Pacific International Exposition while still in school. Branching out on his own, he received a number of important commissions for industrial buildings for the Pacific Gas & Electric Company, and he was the architect for three structures on the grounds of the San Francisco World's Fair, known as the Golden Gate International Exposition, which opened in 1939.

ANOTHER BRAND THAT WOULD be celebrated across not only California but also the entire West was Lucky Lager.

While many of the great breweries in twentieth-century American brewing history trace their heritage back into the previous century, the General Brewing Corporation is an example of a brewing company that did not exist before Prohibition but became a major player in the years following. General began operations at 2601 Newhall Street in San Francisco in 1934, less than a year after the Twenty-first Amendment went into effect.

Clearly, the crusty corporate name was not right as a brand name, so the search was on for the correct appellation for General's flagship lager. A brainstorming session conjured up a cluster of suggestions that are all lost to time. The winner that survived the discussion would soon become a legend in America's Far West. An affinity toward alliteration led to the adoption of the name "Lucky Lager," universally known as "Lucky." With

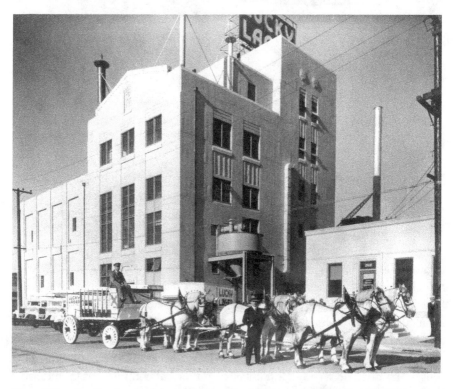

General Brewing Corporation's huge plant on Newhall Street, which opened in 1934, was the largest new brewery opened in San Francisco for the remainder of the twentieth century. From here, the Lucky Lager brand was distributed across the state, rising eventually to regional prominence. *Author's collection.*

this in mind, the General Brewing Corporation later renamed itself "Lucky Lager Brewing"—twice. Over the coming decades, the corporate name would revert back and forth to General, and there were years when the two existed as separate, but associated and interrelated, entities.

As the great engine of Acme was churning across the West, Lucky Lager had hit the ground running. The brand-new Newhall Street plant of General Brewing, with its seven-story tower and mission-style red tile roofs, had become one of San Francisco's major brewing centers soon after the first kegs of Lucky Lager had rolled out the door. It was able to accommodate the demand for Lucky Lager through the waning years of the Depression and into World War II. However, after World War II, California's population exploded as its economy boomed. The thirsty workers needed more and more beer, and California's home-grown brewing companies were anxious to oblige.

Lucky Lager quickly became an important cultural fixture, promoting itself in everything from billboards near Seals Stadium—across the street from the Rainier Brewery—to sponsorship of popular radio programs. One of the best remembered of the latter was *Lucky Lager Dance Time*, a live music program that aired on San Francisco station KSFO in the late 1940s.

For Lucky Lager, celebrity endorsements played a role in its advertising. While many beers used sports figures, Lucky Lager landed Arthur Fiedler, the conductor of the Boston Pops Orchestra, who came west in 1954 to serve as the summer conductor of the San Francisco Symphony Orchestra. It turned out that Fiedler was not only a beer lover but also a fan of prize fights. The conductor quaffed his first Lucky at a fight in San Francisco, and his comments led to an advertising campaign.

"I like watch boxers in action," said Fiedler. "Looking for champions is a hobby of mine. That's how I found Lucky Lager. It's the champion of beer. It's great to relax with a cold bottle of Lucky Lager. Every glass tastes just as smooth as the last."

WHEN IT CAME TO advertising, one clever campaign had literally made Acme the "talk of the town" in San Francisco. This of course was the legendary "Do YOU Do It?" ad blitz that rolled out in 1950. It is still talked about among beer advertising old-timers. Billboards around the city were plastered with slogans claiming that "Outfielders Do It," "Left Fielders Do It," "Fly Casters Do It" and even that "Welders Do It." Eventually, the billboards would claim that everyone from acrobats to "die Besten Braumeisters" (the best brewmasters) were doing "it."

The campaign was clearly a takeoff on Cole Porter's memorable "Birds do it, bees do it, even educated fleas do it." However, where Porter clearly stated that "it" was "falling in love," for the Acme campaign, "it" was drinking Acme beer. Clearly, Acme was playing that slightly sexy double entendre game that is so loved by advertising agencies.

More than two hundred billboards were pressed into service for the campaign, and thousands of little lapel buttons were distributed with the legend "Do YOU Do It?" Airplanes with flashing neon signs claimed that "Dracula Does It," and five thousand sets of trick cards went out claiming that "Magicians Do It."

The campaign raised few eyebrows when fielders and welders were doing "it," but when the billboards went up with the phrase "Telephone Girls Do It," the buzz around San Francisco became a roar. Executives at the Pacific Telephone & Telegraph Company bristled at the presumption that their female employees were doing either the "it" implied by Acme's double entendre or that explicitly suggested by Cole Porter.

The columnists at San Francisco's daily papers chattered about the "telephone girls" for weeks. Bob de Roos said, "The telephone company executives—who regard the ladies in their employ as sacred charges—writhe and groan, particularly when one billboard was pasted upside down which seemed to make everything that much worse."

The *San Francisco Chronicle*'s legendary Herb Caen put it into perspective when he wryly observed "The Big Brass of the phone company and the phone workers' union are baring their fangs at a certain San Francisco beer company for advertising brightly around town: 'Telephone Girls Do It!' All the ad means, natchilly, is that phone goils drink that certain brand of beer. Dear oh dear."

Ultimately, Acme would remove the telephone girl billboards, but the campaign had worked. Even against the backdrop of increased competition, Acme had grabbed a 60 percent market share. A new surge of buttons claimed that Acme was preferred "6 to 4."

Both Lucky and Acme billboards lined the highways and byways throughout California as their breweries pumped out volumes that dwarfed what the other companies produced at their plants in the Golden State. In parallel, both Lucky and Acme rose to prominence as the leading brands of beer brewed in California. This ascendancy coincided with the Golden State's growing into prominence as the most populous and economically powerful state in the United States.

The unprecedented national prosperity of the 1950s—especially in California—promised great things for consumer products companies. The

expanding economy made the road ahead look like clear sailing. While San Francisco had been California's major metropolis for the better part of a century, it was eclipsed by Los Angeles before World War II, and the major postwar population growth in the Golden State was in Southern California. In 1935, Acme had been the first California brewer with major operations in both San Francisco and Los Angeles, and General, renamed Lucky Lager Brewing Company in 1948, went south in 1949 to build a plant in Asuza, twenty miles inland from downtown Los Angeles.

FROM THE 1930s TO the early '50s, brands such as Acme and Lucky Lager owned the statewide California market, but larger brewing companies—including the national giants, as well as major regional brewers from elsewhere in the country—saw the economic opportunities of staking out a place for themselves in the exploding California economy.

Acme's selling point was that, as a light lager, it "quenches." By mid-century, beer was being seen primarily as a thirst quencher. *Author's collection.*

The national breweries, which had hardly been a factor before World War II, were gaining and gaining faster than anyone imagined. The major national brewers would reach their brewing operations into the Golden State in the early 1950s.

Pabst arrived in 1953, acquiring the Eastside Brewery in Los Angeles. Meanwhile, the rapidly growing San Fernando Valley, immediately north of the city of Los Angeles, was emerging as the archetypal postwar American suburban landscape. Into this valley went the two largest brewing companies in the United States. Both Schlitz and Anheuser Busch opened new brewing plants in "the Valley" in 1954. The focus of the nationals was definitely on the Southland.

"The new
ⱭCME can
looks
wonderful

ⱭCME
LIGHT DRY BEER

...and just wait 'til you taste the beer!"

In 1950, Acme rolled out a new can that was designed to look like beer in a glass. *Courtesy of the North Coast Brewing collection.*

The Anheuser Busch plant at Fairfield, fifty miles northwest of San Francisco, was not opened until 1976.

A fourth player among those ambitiously reaching for national prominence was the Falstaff Brewing Corporation of St. Louis. It chose Northern California rather than the Southland, buying the Pacific Brewing & Malting facility—formerly Fredericksburg Brewery—in San Jose in 1952.

In 1953, the same year that Pabst bought into Los Angeles, an ambitious outsider acquired the property of an earlier ambitious outsider in San Francisco. After nearly four decades, Rainier sold the massive brewing plant on Bryant Street, across the street from San Francisco's Pacific Coast League baseball park, and withdrew into its home turf in the northwest.

The buyer was the Theodore Hamm Brewing Company of St. Paul, Minnesota. Like Falstaff, it was a well-established regional company with national ambitions. It arrived in San Francisco with an enthusiasm driven by the creative genius of the Campbell-Mithun advertising agency, which had memorably defined Hamm's as the beer "From the Land of Sky-Blue Waters" and now helped drive Hamm's distribution throughout the West. Between 1951 and 1954, Hamm's moved from fifteenth to eighth place among American breweries and was eager for a greater place in the scheme of things.

The most conspicuous manifestation of Hamm's presence in San Francisco was a massive neon beer glass on the brewery roof, which dominated the skyline of San Francisco's South of Market area for nearly two decades. The 39-foot glass, with its 2,300 feet of yellow and white neon tubing, was visible throughout the city and from the Bay Bridge as it was "filled and drained" tens of thousands of times before the brewery was finally closed in 1972.

With the arrival of Hamm's, the fortunes of the once-great Acme declined precipitously. In 1954, as the big breweries crowded into California, Acme went on the block. The company, along with both its San Francisco and Los Angeles breweries, was acquired by Liebmann Breweries of New York. The idea was to brew Liebmann's famous Rheingold brand on the West Coast. This venture ended four years later. Liebmann pulled out of the Golden State, selling the Los Angeles brewery to Hamm's in 1958.

For two decades, the thirty-nine-foot neon beer glass on the roof of the Hamm's brewery on Bryant Street dominated the skyline of San Francisco's South of Market area. The brewery, built by Rainier Brewing in 1916, was sold to the Theodore Hamm Brewing Company of St. Paul, Minnesota, in 1953, stopped brewing in 1972 and was repurposed, no longer as a brewery. The great beer glass disappeared. *Author's collection.*

Acme's nearly new San Francisco brewery, which had been heralded in 1942 as "one of the world's most beautiful industrial buildings," was simply closed in 1958. It was demolished for an off-ramp from San Francisco's Central Freeway. No trace remained. Long considered an eyesore, the Central Freeway itself was completely demolished by 2003. The Los Angeles brewery was used to brew Hamm's until 1972, at which time it was closed forever.

In 1963, nine years after coming to Southern California, Schlitz, the number two national brewing company, entered San Francisco through its acquisition of the Burgermeister Brewing Company, whose plant on Tenth Street had recently been upgraded to a 900,000-barrel annual capacity. Adding Burgie to the Schlitz portfolio boosted sales nearly 20 percent. Ironically, the big Burgermeister facility, which was formerly the Milwaukee Brewery, was now owned by a Milwaukee company. Schlitz remained for just a relatively short time, selling the property to Meisterbrau of Chicago in

1969. Two years later, Falstaff acquired the Tenth Street brewery as part of its nationwide archipelago of holdings.

By the 1960s, more than a decade of nationwide industry consolidation had virtually eliminated locally based brewing companies everywhere and had entirely changed the complexion of American brewing. In California, the tide of mergers and acquisitions had left Lucky Lager (still alternately operating under the General brewery corporate name), with operations in San Francisco and Los Angeles, as the largest home-based brewing operation in the state.

As the national breweries had come to dominate the West, a spontaneous cultural phenomenon quickly came into place in beer advertising. Menus in bars and restaurants made widespread use of it. This phenomenon was the strict delineation between home-grown "western beer" and "eastern beer," the beer made by the interloping nationals. Clearly, Lucky Lager was "western beer," and when Acme and Burgie fell, it became the western beer within California. With this in mind, it is easy to understand why the brand adopted the double entendre tag line: "It's Lucky When You Live in California."

As Lucky Lager grew in prominence throughout the West during the 1950s and '60s, the line was modified to read, "It's Lucky When You Live in America."

During this period, Lucky Lager successfully operated a multi-site regional empire that paralleled in geographic scope those being created by the major second-tier brands such as Falstaff and Hamm's. The first major step toward transforming Lucky from a California to a regional brand came in 1950 with the acquisition of the Interstate Brewing Company in Vancouver, Washington, directly across the Columbia River from Portland, Oregon. Another step, this one toward securing the role of Lucky Lager as the leading brand in the Mountain West, came in 1960 with the acquisition of the Fisher Brewing Company in Salt Lake City. Bringing the facility online as a Lucky operation led to the brand having major prominence in the northern Rockies during the 1960s. At the time, Coors was not yet available in all the mountain states.

Within a few years, Lucky/General was feeling the weight of the national brewing companies. A generation later, craft brewers managed to outmaneuver the national brands with superior quality, but in the 1960s, the regionals erroneously believed that they had to compete for shelf space on the basis of price point. Ultimately, it would be their undoing. To make ends meet, the company began divesting property. The Azusa site was sold to Miller Brewing in 1966, and the Salt Lake City plant was simply closed in 1967.

By the 1970s, both General Brewing and Falstaff, owners of San Francisco's last two surviving large-scale breweries, were strapped for cash

The Lucky Lager "X" label—whether die-cut like this one, or not—became ubiquitous throughout the western United States during the mid-twentieth century. *Author's collection.*

and classic targets for acquisition. In 1975, it happened. Both companies were acquired by the eccentric real estate and brewery acquisitions tycoon Paul Kalmanovitz and incorporated into his S&P Holdings, which included the once-powerful Pabst Brewing of Milwaukee. In keeping with Kalmanovitz's drastic downsizing paradigm, he closed all of their breweries except the one brewing Lucky Lager in Vancouver. In 1985, he dismantled and shipped it to Zhaoqing, China. He died two years later, leaving a $500 million fortune that was pawed over in court for years. He legacy is that, although he lived and died in Tiburon, within sight of San Francisco, almost no one in the San Francisco brewing scene remembers him or has heard his name.

The vast Milwaukee/Burgie/Schlitz/Falstaff brewery complex on Tenth Street was torn down and replaced by a massive Costco warehouse store. The original Lucky/General brewery on Newhall Street survived. It became a Planter's Peanuts facility for a while and was later operated by U-Haul as a storage warehouse. The former Hamm's brewery, San Francisco's largest when it was built by Rainier, also survived. For a while it was repurposed as

a center for San Francisco's punk rock scene, a place known as "the Vats." Beginning in the 1980s, it was remodeled and parts of it rented out as offices and showrooms.

Of the brand names, Burgie disappeared, but Lucky Lager survived for a while, contract brewed by third-party breweries. In the 1990s, it was revived for a time as the "house brand" of the unrelated Lucky grocery store chain. It is still brewed in Canada by Labatt and is seen occasionally in parts of the United States, but not in San Francisco. Hamm's ceased to be an independent company in 1965, and its flagship brewery in St. Paul was closed in 1997. The brand exists under the ownership of Miller Brewing, later a part of SABMiller, but it is not seen in San Francisco.

The Acme brand name, though, survives. Through the 1970s, Blitz-Weinhard of Portland, Oregon, continued to brew small quantities for the California market, but after Blitz gave up the trademark, it faded back into obscurity. It was briefly revived in 1987 by Xcelsior Brewing, a microbrewery in Santa Rosa, about an hour north of San Francisco, but that business folded in 1989. Again, Acme disappeared, recalled only by a handful of nostalgic fans.

Among the latter were Mark Ruedrich and Tom Allen, the proprietors of the North Coast Brewing Company, a microbrewery born in 1988 on California's Mendocino County coast. Not only were they Acme fans and Acme memorabilia collectors, but they also owned a brewery. In 1996, they brought these interests together, adding Acme to their product line, where it remains. It is a true testament to the cultural significance of Acme within California that, long after its demise in its original form, the brand was revived by not one but two modern craft breweries.

THE ORIGINS OF CRAFT BREWING

In the shadow of the great mass-market breweries that dominated San Francisco's brewing scene—and parts of its skyline—in the 1950s and '60s, few people around the Bay Area noticed the tiny Anchor Brewing Company. San Franciscans who dropped by their local tavern for a beer didn't notice it either because Anchor had few accounts and a spotty reputation. By all logic, Anchor should have faded away like most of the small brewing companies throughout the United States. Indeed, it had.

In 1959, Joe Allen, who was one of the men who had saved Anchor after Prohibition, had decided to finally close the doors. Production was down to less than seven hundred barrels annually, half of what it had been after Prohibition—and less than a day's production for even the average large brewing company. However, a man named Lawrence Steese stepped in to buy the company and hire Allen to help him. Anchor was reborn in 1961 at 541 Eighth Street.

In an era when the American brewing industry aspired to a standard in which "flavor neutral" was a cherished goal and when "crisp" and "cold" were the best adjectives the industry could devise to communicate with consumers about their product, Anchor defied the dominant paradigm by brewing beer that actually had flavor. Unfortunately, much of the consuming public had forgotten that beer should have flavor. In the early 1960s, there was no way of predicting that little Anchor would soon herald a reversal of this trend.

At Anchor, production was intermittent, and so was quality, but when you could find Anchor Steam Beer, and when it was good, it could be very

good. One of those who first championed Anchor Steam and who put his money where his ardor lay was Fred Kuh, the owner of the Old Spaghetti Factory, a popular restaurant on the North Beach shoulder of San Francisco's Telegraph Hill. It was the only draft beer he served, and he was proud to do so.

By 1965, one of the people who found Anchor Steam at the Old Spaghetti Factory enjoyed it and kept coming back for more was a twenty-seven-year-old Stanford University graduate from Newton, Iowa, named Frederick Louis Maytag III. Having traversed Japan on his motorcycle in 1959 and by bicycle in 1962, Fritz Maytag was now living in La Honda, about an hour south of San Francisco, and had recently dropped out of the Japanese language graduate school program at Stanford.

One evening in early August 1965, Maytag was standing at the end of the bar at the Old Spaghetti Factory enjoying a glass of Anchor when Fred Kuh asked whether he had ever visited the Anchor Brewing Company brewery.

Maytag replied that he had not.

"You ought to see it," Kuh suggested. "It's closing in a day or two, and you ought to see it. You'd like it."

"I went over the next day and bought controlling interest for practically nothing," he told Robert Sullivan of the Stanford alumni magazine in 1996. He had gone through the door not planning to do this, but now he had. Like his forebears—his great-great-grandfather Frederick Maytag, who started the Maytag Washing Machine Company in 1893, or his father, Frederick Maytag II, who started making Maytag Blue Cheese—Fritz Maytag was a natural entrepreneur.

As he later told another interviewer at KQED radio and has often said, "The idea of owning a brewery, even if it was a joke of a brewery, was a thrilling thing."

"The brewery had been kept alive more by the enthusiasm for the idea than enthusiasm for the beer," he explained. "When it was good, which was not too often, it tasted very much like what we have here today. We wanted to use the original recipe. But they'd been adding corn syrup sometimes, to save money. I went back to all barley malt. I set up a little place in the brewery—'the lab'—and brought down my microscope. I was the kind of guy who had a microscope."

The Anchor Brewing Company was a primitive place. Maytag relates that he found himself with "the last medieval brewery in the world." He is also quick to add that, with the microscope under his arm, he turned it into "the most modern brewery in the world." To do this, he compiled one of the world's

most extensive libraries devoted to the history and science of brewing, and he actually read these books. He toured the world, looking at some of the biggest breweries in Europe and America and comparing their methods to his own. In so doing, he took the hyperbole out of the audacious assertion that Anchor possessed "the most modern small brewery in the world." In a conversation with this author, he reflected that given the nature of his state-of-the-art equipment and practices, the argument could be made that Anchor had been transformed into the most modern brewery of any size in the world.

He refined Anchor Steam Beer and began adding to his product line. In 1972, he became probably the first American brewer to introduce an authentic, top fermented, highly hopped and rich porter since Prohibition. Indeed, this was long after most British brewers had eliminated porter from their product lines in its country of origin. In 1975, he introduced Old Foghorn Barleywine, another style that had long been abandoned by the breweries of Britain and the United States in its traditional and authentic form.

Also in 1975, Fritz Maytag began the tradition of producing an annual Christmas ale, a beer in the genre of the spiced beers for winter release that had once been common in Britain and was occasionally seen the United

Fritz Maytag at work in the Anchor brewhouse, circa the late 1960s. *Courtesy Anchor Brewing*

Beginning in 1975, Anchor Brewing has produced a Christmas ale every year. This one dates from 1985. Though stylized Christmas trees have been used periodically, another Anchor tradition has been to feature specific tree species identified by their scientific names. *Author's collection.*

States but was virtually unknown on either side of the Atlantic since before World War II. Maytag has described the 1975 Christmas ale, which was Anchor's first attempt at an ale, as "a disappointment," but the tradition proved popular with consumers and "Our Special Ale" became a permanent part of the Anchor portfolio. Each year, a different recipe produced a distinctly different Christmas ale, with spices being added beginning with the 1987 version. Maytag points out that the 1987 Christmas ale was identical to the "bride ale" he brewed a year earlier for his January 1987 wedding.

The specific mix of spices that is used each year in the Anchor Christmas ale remains a closely guarded secret. The production of the annual Christmas ales is one of the Anchor traditions of which Maytag is most proud.

In 1975, Fritz Maytag released the first version of his Liberty Ale on the eve of the 1976 bicentennial commemoration of the Declaration of Independence and the United States. Because Maytag "likes to be ahead of the crowd," he brewed the first Liberty Ale on (to paraphrase Longfellow's poem) "the eighteenth of April in '75," "thereby celebrating the midnight ride of Paul Revere." The 1983 Christmas ale became the second and current version of Liberty Ale.

Through the years, Maytag brewed a number of other limited-release beers, of which the most esoteric was Ninkasi, named for the Sumerian goddess of beer. What came to be known as the Sumerian Beer Project began when he became aware of the 3,800-year-old poem "Hymn to Ninkasi"

and realized that it involved a detailed recipe for making Sumerian beer. He wondered aloud whether it would be possible for a modern brewer to brew such a beer and answered his own question in the affirmative. Working with Dr. Solomon Katz, a bioanthropologist at the University Museum of Archaeology and Anthropology at the University of Pennsylvania, he re-created the beer, even going as far as to bake and mash *bappir*, loaves of barley bread of the type used by Sumerian brewers. Hops were unknown to Sumerian brewers, so dates and honey were used because the poem mentions something "sweet" was an addition to the brew. The first public unveiling of Ninkasi, which took place at the 1989 Microbrewers Conference in San Francisco, is still remembered by those of us who were there as a milestone moment.

Fritz Maytag's creativity, backed by a virtually unprecedented attention to science and technical detail, would inspire a new generation of brewers and initiate and perpetuate the craft brewing movement.

The first of this generation was Jack McAuliffe, who had been an active homebrewer while with the U.S. Navy in Scotland. Starting from scratch, he founded the New Albion Brewing Company in Sonoma, an hour north of San Francisco, in 1976. The name was a reminder both of John Burnell's Albion Brewery and of Sir Francis Drake having named the area of Northern California north of the Golden Gate as "New Albion." Like

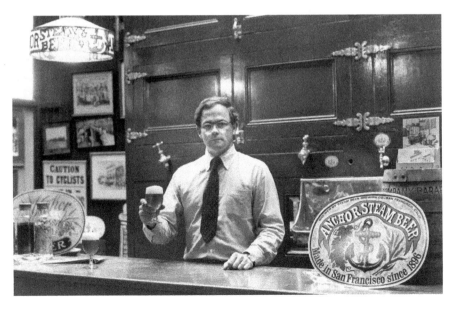

A young Fritz Maytag hoists a glass of Anchor Steam in the taproom of Anchor's Eighth Street brewery. *Courtesy Anchor Brewing.*

Maytag, McAuliffe wanted to brew beer that had a full and pleasing flavor, and like Maytag, he did so without knowing that he would have a hand in changing history. Though the output was minuscule, the New Albion beer was well received, and those who visited were fascinated. Among them was Michael Lewis, who headed the brewing studies department at the University of California in Davis and who brought his students to visit McAuliffe's operation. New Albion survived only until 1982, and McAuliffe never started another brewery, but he had made an impression.

Among those New Albion made an impression on was another homebrewer named Ken Grossman, who in 1979 became one of the founders of the Sierra Nevada Brewing Company in Chico, California. Others followed, mostly in Northern California in the early years, but soon, they were cropping up throughout the West and even as far away as the East Coast. In the beginning, these little breweries were so small that they could not even be called mini-breweries—so the term "microbrewery" was born.

The original definition of a microbrewery was a brewery with an annual output of fewer than 3,000 barrels—McAuliffe's was around 450—but by the end of the 1980s, this threshold increased to 15,000 barrels as the demand for microbrewed beer first doubled and then mushroomed.

Another new entity born of the microbrewery revolution was the "brewpub," a microbrewery that both brewed and served its beer to the public on the same premises. Unlike a microbrewery, which distributes through retailers, the primary market for the products of a brewpub are the customers under its own roof. As time went on, some brewpubs bottled their beers for sale both to patrons and retailers, while some microbreweries also operated on-premises pubs, so the distinction between the two became somewhat blurred. Both, however, share a commitment to their own unique beers. As with the first generation of microbrewers, the early brewpublicans entered their trade out of a love for brewing and an interest in distinctive beer styles.

Brewpubs had existed in the United States in the eighteenth and nineteenth centuries. However, after Prohibition, it was illegal in most states and Canadian provinces to both brew beer and sell it directly to the public on the same site. Changes in local laws since the early 1980s rescinded these outdated restrictions and made it possible for brewpubs to become widespread.

The first American brewpub since Prohibition was opened in Yakima, Washington, in 1982 by Bert Grant. It was America's first brewpub in more than a century. The first in California was Mendocino Brewing in the appropriately named town of Hopland, about two hours north of San Francisco, which opened in 1983.

San Francisco's first brewpub, and the first new commercial brewing company in the city in over half a century, was the San Francisco Brewing Company, opened in 1985 by Allan G. Paul. The venue was the old Andromeda—later Albatross—Saloon at the corner of Pacific and Columbus Avenues, only one block from where Francis G. Hoen had established San Francisco's first commercial brewery around 138 years earlier. The Andromeda was famous for, among other things, having once employed future heavyweight champion Jack Dempsey as a bouncer. Paul polished off the elegant mahogany back bar, installed a 1916 Pukka Walla ceiling fan, developed a pub menu and brought in an eclectic range of live music.

Using a brew kettle handmade by master coppersmith Fred Zaft and the slogan "From Grain to Glass," Paul brewed around one thousand barrels annually of such beer as Gripman's Porter, Pony Express Ale, Andromeda Wheat Beer, Alcatraz Stout and this author's favorite, a Munich-style lager. This beer was called Emperor Norton after the eccentric, though beloved, character from San Francisco's nineteenth-century history.

British-born Joshua Abraham Norton was a wealthy businessman who lost his fortune in the Peruvian rice market but reinvented himself as "Norton I, Emperor of the United States and Protector of Mexico." He was tolerated and even encouraged by San Franciscans, who enjoyed his colorful antics. Among the promulgations issued by the "emperor" was the then-absurd decree that a bridge be built between San Francisco and Oakland. This was finally done in 1936, nearly six decades after Norton's death.

The second brewpub in San Francisco was the

This label from the San Francisco Brewing Company, circa 1985, includes Allan Paul's "From Grain to Glass" slogan. *Author's collection.*

Seacliff Café Restaurant and Vest Pocket Brewery, squirreled into a tiny space at 1801 Clement in the outer Richmond District. It was opened in 1987 by Klaus Lange, the German-born restaurateur who had started the elegant Café Mozart in 1974. A specialty was Dutch Brown Ale, Lange's interpretation of *oude bruin* (old brown), a beer that is indigenous to the Netherlands.

The next among the first generation of new San Francisco breweries was the Twenty Tank Brewery, established in 1990 on 316 Eleventh Street by Reid and John Martin, the founders of the Triple Rock Brewery in Berkeley. Twenty Tank arrived here in the South of Market area on the eve of that district's becoming a center of entertainment and nightlife for which it would be known into the twenty-first century. Indeed, with its high ceilings and industrial ambiance, the Twenty Tank would be right at home among the current generation of San Francisco's South of Market brewpubs.

In 1992, the Gordon Biersch brewery-restaurant chain arrived in San Francisco. This enterprise had been born in 1988 in Palo Alto, near the Stanford University campus, created by a partnership between chef Dean

At the Twenty Tank Brewery, the flagship ale was Kinnikinick. The coasters directed patrons to "always pick a 'nick." *Author's collection.*

Biersch and a brewer named Dan Gordon, a graduate of the five-year brewing program at Weihenstephan in Germany. At a time when brewpubs typically served simple pub food, their idea was to combine on-premises brewing with a full-service restaurant and for this template to evolve into a chain of restaurants. They had opened in San Jose in 1990, and their San Francisco restaurant on the Embarcadero near Harrison Street was the third of around a dozen locations they would open.

In 1993, the first generation of new San Francisco breweries was rounded out by the establishment of Café Pacifica at 333 Bush Street, near Union Square. It was a unique concept in the form of a Japanese restaurant with on-premises brewing. The restaurant later did business as the Sankt Gallen Brewery, a reference not to the city of Sankt Gallen in Switzerland but to the Sankt Gallen Brewery in Atsugi, Japan. A couple of blocks away, the E&O Trading Company opened a second Asian-themed brewery-restaurant in the environs of Union Square at 314 Sutter Street.

Sadly, none of the first generation of new San Francisco breweries survives today. The smallest of the five were the first to go. Klaus Lange closed his Vest Pocket Brewery in 1989, only two years after it began, and the Pacifica/Sankt Gallen operation closed in 1996.

The Twenty Tank Brewery, a favorite of this author, had signed a ten-year lease in 1990, so in 2000, it was gone. Ironically, it took several years to lease the space, during which time the Twenty Tank's neon mug hung forlornly over Eleventh Street.

The San Francisco Brewing Company, another of the author's fondly remembered haunts from the latter twentieth century, remained both a popular destination and an important fixture on the brewing scene, a must for local and visiting beer connoisseurs. Allan Paul himself remained an important fixture on the San Francisco brewing scene and was one of the key individuals in the birth of the San Francisco Brewers Guild in 2004. By 2009, a mixture of financial troubles and increasingly burdensome city regulations squeezed San Francisco Brewing to the breaking point. It, too, joined the lamentable list of former San Francisco brewing companies, and Paul relocated to Texas.

The E&O operation on Sutter Street was also still around during the early days of the San Francisco Brewers Guild, but while the restaurant remained under various incarnations, the brewing operation was closed.

Gordon Biersch, meanwhile, expanded nationwide and was acquired in 1999 by the Big River brewery-restaurant chain, which, in turn, became part of CraftWorks Restaurants and Breweries that also owned the similar Rock Bottom brewery-restaurant chain. In 2012, the conglomerate closed the

The author (standing) at a signing for his book *Beers of North America*, which was held in 1991 in the brewhouse of the San Francisco Brewing Company. *Author's collection.*

popular and successful Gordon Biersch location on the Embarcadero in San Francisco, citing a disagreement with the landlord over lease terms.

Though the first generation had come and gone, a second generation began opening their doors as the brewing community said farewell to the century that had delivered the tribulations of Prohibition, flavor neutral beer and an industry consolidation that had brought about the extinction of small and midsized breweries nationwide.

In San Francisco, though the pioneers were fading away, there were newcomers who would take root and flourish in the environment where their predecessors had proven there to be a strong consumer demand, both for unique, hand-crafted beer and for an inviting place in which to enjoy it.

6
CRAFT BREWING COMES TO STAY

As the second millennium was coming to a close and as many doomsayers theorized that dark things would come forth to plague mankind at the turning of Y2K (as the year 2000 was then called), a second generation of new, small craft breweries began to appear across San Francisco. The dark things that they brought forth were neither theoretical nor malevolent but, instead, beautiful. They came brimming in pint glasses, and they were so good as they crossed the palate that San Franciscans demanded another glass of those dark things, as well as the amber things, the golden things and the ruby-red things in those cool pint glasses with the foam on top.

The first of the second generation that came to stay was the ThirstyBear Brewing Company, a brewery-restaurant that opened at 661 Howard Street in September 1996. The founder was Ron Silberstein, a former attorney, who traded his law practice for a brew kettle. He notes that he "envisioned a space that combined artisan, hand-crafted beers with artisan Spanish cuisine—a cuisine that could never be confused with pub grub or typical brewpub food."

The name of the brewery is drawn from a 1991 newspaper article that Silberstein had taped to his refrigerator about a Ukrainian man named Victor Kozlov, who was attacked by a bear that proceeded to steal the beer out of his hand. Victor has never visited Howard Street for a beer, but several of his cousins did drop by.

On a visit to the brewery, this author noted the irony that, while Silberstein celebrated Kozlov, he named his brewery after the bear. Both

Brewmaster Brenden Dobel presents a pair of pints at the bar at ThirstyBear Brewing Company on Howard Street. *Bill Yenne photo.*

Silberstein and head brewer Brenden Dobel, who joined ThirstyBear in 2002, expressed amusement at this observation.

Turning to their restaurant, they go on to say that they work "with numerous local farmers, artisan bakers, cheese makers and incorporates the finest specialty ingredients from Spain, to create a truly unique farm to table Spanish style cuisine. The restaurant is the perhaps the only brewpub in the United States to pair Spanish style tapas and paellas with its handcrafted beers."

Today, ThirstyBear ranks as the oldest brewpub or brewery-restaurant in San Francisco and the second-oldest brewery after Anchor. The company brews and serves more in-house beer on premises than any other. Larger breweries, such as Anchor and Speakeasy, are mainly production breweries.

SPEAKEASY ALES & LAGERS was one of a trio of breweries that started in 1997 and grew into important fixtures on the San Francisco brewing scene—mainstays of the San Francisco Brewers Guild. The others are Magnolia and Beach Chalet. Unlike these, which originated as brewery-restaurants, Speakeasy started as, and remains, a production brewery, though it does have a small taproom. The brewery was founded at 1195 Evans Avenue in the Butchertown District, a short distance from John Burnell's Albion Castle, by homebrewers Forest Gray, Steve Bruce and Mike Bruce. Their being located in a "secret" location in a distant corner of the city led to the naming of the brewery after a Prohibition-era speakeasy and to their using a Roaring Twenties, gangster-era theme for their products. The original beer, and still the flagship, was 6.1 percent ABV, 50 IBU Prohibition Ale. In turn, they added 6.5 percent, 60 IBU Big Daddy IPA, which would become San Francisco's best-selling IPA and which they call "a hop-head's delight."

Speakeasy brews numerous beers, with the year-round brands being categorized as its "Usual Suspects." In addition, the line includes 5.5 percent ABV, 38 IBU Scarlett Red Rye Ale; 5.6 ABV, 50 IBU Tallulah Extra Pale

Brian Stechschulte pours a pint at the bar in the taproom at Speakeasy Ales & Lagers on Evans Avenue. *Bill Yenne photo.*

Ale; the assertive 8.5 percent, 100 IBU Double Daddy Imperial India Pale Ale; and 7.5 percent, 35 IBU Payback Porter. Added to the roster in 2014 was Metropolis Lager, with 5.3 percent ABV and 47 IBUs. As Speakeasy notes, the flavor profiles of its products are driven by "the brewery's passion for intense, in-your-face flavors that were still balanced and approachable."

On premises, numerous changes have been made on Evans Avenue. Where once the brewery hosted informal Friday-night parties on its brewery floor, it opened a new taproom in 2011 that allows patrons to enjoy the Usual Suspects and their seasonal brethren six days a week. In 2015, as the staff had increased ten-fold from the original four, a new sixty-barrel brewhouse, malt handling system, fermenters, centrifuge and canning line were installed. Annual production capacity increased to ninety thousand barrels, and Speakeasy launched its Session 47 Series, the first Speakeasy beer in cans. Distribution, meanwhile, expanded from the Bay Area to all of California and then to New York, Boston and other East Coast locations.

ANOTHER OF SAN FRANCISCO brewing's class of 1997 was the Beach Chalet Brewery and Restaurant, which was started by Gar and Lara Truppelli and Timon Malloy at 1000 Great Highway, across the street from the Pacific Ocean at the foot of Golden Gate Park.

The name was an obvious choice, given that the Spanish Colonial Revival–style beach chalet itself had been a fixture since it was built in 1925 to cater to beachgoers. Designed by famed architect Willis Polk, its main floor was decorated in 1936–37 with murals by the equally celebrated painter Lucien Labaudt and sculpture work by Michael von Meyer. During World War II, it was used by the U.S. Army to house coastal defense artillerymen, and afterward, it was leased by the Veterans of Foreign Wars as a meeting spot. Gradually, the Beach Chalet deteriorated, and by the 1970s, its main floor had become a seedy biker bar, and it was later locked up and abandoned for nearly two decades. After an intensive renovation in the 1990s, it reopened as a visitor center for Golden Gate National Recreation Area.

In 2004, seven years after the opening of their Beach Chalet Brewery and Restaurant, the Truppellis opened a second restaurant on the back of the building that faced eastward into Golden Gate Park. Again the name was obvious, and the Park Chalet was born. The cuisine is slightly

Opposite, bottom: The lobby at the Beach Chalet is decorated by murals done in 1936–37 by the famous painter Lucien Labaudt. The staircase leading to the restaurant is decorated by carvings by sculptor Michael von Meyer. *Bill Yenne photo.*

The Beach Chalet Brewery and Restaurant is located in a Spanish Colonial Revival–style building of the same name that was designed by renowned architect Willis Polk and completed in 1925. *Bill Yenne photo.*

The Park Chalet Restaurant (right) faces Golden Gate Park, while the Beach Chalet Restaurant (left) faces the Pacific Ocean. The brewery is in between. *Bill Yenne photo.*

different at the two locations, but the Park Chalet serves beer made next door.

Brewed under the direction of brewmaster Aron Deorsey, the beer produced at the Beach Chalet includes a variety of seasonal releases, as well as a regular lineup. Among the latter grouping are 4.8 percent ABV, 13 IBU VFW Golden Ale; 4.1 percent, 13 IBU High Tide Hefeweizen; 5.5 percent, 43 IBU California Kind Pale Ale; 6.5 percent, 73 IBU Presidio IPA; 5.6 percent, 21 IBU Riptide Red Ale; and 5.6 percent, 42 IBU Fleishhacker Stout. The latter recalls the famous Fleishhacker Pool, which was located nearby and was one of the largest freshwater swimming pools in the world during its heyday from 1925 to 1971. It was the creation of the San Francisco philanthropist Herbert Fleishhacker, who also founded the Fleishhacker Zoo, which is now the San Francisco Zoo.

ROUNDING OUT THE TRIO of breweries that comprise San Francisco's class of 1997 is the Magnolia Gastropub and Brewery at the opposite end of Golden Gate Park at 1398 Haight Street in the heart of Haight Ashbury.

Magnolia was the creation of Dave McLean, a one-time homebrewer whose hobby became an obsession, and this led him to a graduate degree from the brewing program at the University of California in Davis.

"There's a sweet spot we strive for and it straddles the edge between tradition/history and the fresh and creative," he writes of his brewing philosophy. "When we hit it, it opens up the pipeline to a rich and complex past, connecting us to the traditions of generations before us, while keeping us squarely in the here and now by expressing our unique perspectives."

He goes on to say that his beer "marries a Slow Food–like respect for tradition with a Grateful Dead–esque approach to inspired creativity." Indeed—as suggested by his location on Haight Street, his Jerry Garcia–esque beard and the reference to the Dead's iconic 1970 song "Sugar Magnolia"—McLean is clearly a fan of the Dead, whom he saw in concert around 150 times. This was instrumental in bringing him to San Francisco.

Slow food, meanwhile, is an international movement begun in 1986 in Italy by Carlo Petrini. Encouraged as an alternative to fast food, slow food endeavors to perpetuate traditional and regional cuisine while promoting agricultural products indigenous to a particular local ecosystem and a farm-to-table philosophy that provides consumers with an appreciation of the places where their food is sourced. McLean's commitment to serious gastronomy is evident in his choice of the term "gastropub."

He goes on to say:

> We as a culture are enriched by the celebration of our food and drink traditions. Those traditions bring us together, remind us of our shared culture, and help strengthen our sense of place and identity. Meanwhile, the Dead, especially Garcia, exhibited an almost pathological curiosity about music that helped build an encyclopedic set of mental references for use in real-time creative expression. That added emotional depth and cultural identity to in-the-moment improvisation. Filtered through our little corner brewpub, this manifests in the beer when we reference and honor traditional brewing styles and methods while adding something modern and fresh to the conversation.

In a conversation with this author, he elaborated on this theme, saying that in slow food, as in music and brewing as he likes to practice it, there is the opportunity for the practitioner to "treat yourself as an artist" and for the artists to then "create an ecosystem around their art and craft."

As with the Dead and with the slow food movement, he explains that he strives in his brewing work to develop "an intense respect for the fan or

consumer, and to treat them as part of the community that surrounds the art or craft."

In 2014, after many years of planning, McLean opened a second, much larger location at 2505 Third Street in San Francisco's "recently rediscovered" Dogpatch District. The new facility is both a brewery and a barbecue restaurant, which was named Smokestack after "Smokestack Lightning," a Howlin' Wolf song covered by the Dead. Here, his slow food, farm-to-table interests come full circle in a unique way. As most brewers sell their spent grain to farmers as livestock feed, McLean sells his to the Devil's Gulch Ranch, a family farm in Marin County, where it is used to feed hogs that are Yorkshires bred with Durocs or Berkshires, the meat from which ends up back on the grill and the table at Smokestack.

Magnolia's new brewing facility behind the Smokestack restaurant is a huge production brewery that supports a wider distribution than was previously possible. While the Magnolia brewery on Haight Street had a 7-barrel brewing system and a 7-barrel fermenter, the Dogpatch location boasts a 30-barrel brewing system, with 240 barrels of fermenting capacity and plans for two more 90-barrel fermenters and a great deal of room to grow.

Three-quarters of Magnolia distribution is within San Francisco, and it is almost entirely to draft accounts. Some Magnolia products are available in growlers at local stores, but the margin is paper thin and is seen more as a means toward brand exposure. Long-term plans call for a bottle line at the Dogpatch brewery, which will allow much greater access to the retail trade.

Heading the roster in the Magnolia portfolio is Proving Ground IPA, with 7 percent ABV and 100 IBUs, which McLean has brewed since the beginning. The longtime biggest selling Magnolia beer, Proving Ground, was recently overtaken by another veteran of the lineup, Kalifornia Kölsch. McLean's interpretation of kölsch, the indigenous beer of the German city of Cologne (Köln), has 4.7 percent ABV and just 15 IBUs. Other beers that are part of McLean's first tier of year-round offerings include Cole Porter, with 4.8 percent ABV and 30 IBUs, and Blue Bell Bitter, with 5.4 percent ABV and 30 IBUs.

McLean favors English-style beers and always has several of his offerings available on cask at both Haight Street and at Smokestack. "I've been an English beer guy all my life," he told this author. "I'm a malt person not a hop person." In the hop-forward California market, he compares this to being like a fish "swimming upstream" but adds that he does favor a balance, rather than creating explicitly malt-forward beers.

Dave McLean, seen here at his Magnolia production brewery behind his Smokestack Restaurant on Third Street, has recently begun to barrel-age some of his beer in whiskey barrels. *Bill Yenne photo.*

As for the broad spectrum of beers beyond the core Magnolia brands, he explains that having the Dogpatch brewery to answer the need for high-volume favorites has allowed him to use the Haight Street brewery to concentrate on more experimental "fun or one-off" beers that he can produce on a whim or for seasonal occasions. He mentions his 4.7 percent High Time Harvest Ale, made with Citra hops from the Hopmeister farm in California's Lake County. With this in mind, he grins with enthusiasm when he speaks of wrapping himself "in the magic moment when the hops are fresh."

Also in this spirit is Tidewater 4-1009, with 4.6 percent ABV and 30 IBUs, which is brewed with malt from the Copper Fox Distillery in Virginia's tidewater country, the makers of Wasmund's pot-distilled, fruitwood-aged

single malt and rye whiskey. He made contact with Copper Fox through having met the distiller's daughter, who lives in the Haight, near Magnolia. McLean also does barrel-aging with whiskey barrels. He chuckles that it is potentially possible for him to serve a boilermaker in which both the beer and the whiskey were once in the same wood.

Another Magnolia neighborhood connection allowed McLean to indulge his interest in English brewing a step further. The father of this neighbor was the owner of Branthill Farm in Norfolk on England's east coast. This farm is the major supplier of Maris Otter, two-row malting barley to breweries throughout Norfolk and beyond. McLean, who is excited to be using malt from an area where barley has been cultivated since Roman times, became the first American craft brewer to brew with Branthill malt. His 4.2 percent, 33 IBU Branthill ESB (Extra Special Bitter) is a celebration of his relationship with the farm.

Speaking of relationships, through the years, Dave McLean's personal connection with members of the Grateful Dead has included his being invited to "curate" the beer list for Terrapin Crossroads, the music venue founded in 2012 in San Rafael by former Dead bass man Phil Lesh. Naturally, Magnolia products were on the list and naturally McLean insisted on making all the keg deliveries to Terrapin personally, where he enjoyed getting to know Lesh. In 2015, Lesh, along with other founding members, including guitarist Bob Wier and drummer Bill Kreutzman, reunited for a series of concerts to commemorate the Grateful Dead's fiftieth anniversary. During this time, Kreutzman, who lives in Hawaii, took an apartment in San Francisco's Dogpatch and—much to McLean's delight—made frequent visits to Smokestack, where he would sit down for a pint with the owner.

WHILE SPEAKEASY CELEBRATES the wild and crazy days of Prohibition, there is another brewery across town that celebrates the constitutional amendment that ended Prohibition: the 21st Amendment Brewery.

Known to friends and family simply as 21A, it was founded in Y2K by a pair of brewing enthusiasts from Southern California who had come north in search of the beer culture that they found lacking in Los Angeles. The two met in a classroom at the University of California at Davis while enrolled in the school's brewing studies program. Nico Freccia was a homebrewer who'd held day jobs as an actor and a restaurant professional. In San Francisco, he had been writing for Tom Dalldorf's *Celebrator Beer News*, the West's largest beer enthusiast publication. Shaun O'Sullivan was a former photographer and a veteran assistant brewer at Berkeley's Triple Rock Brewery. Together,

A view of the restaurant at the 21st Amendment Brewery on Second Street, as seen from the mezzanine. *Bill Yenne photo.*

they started their brewpub at 563 Second Street, just three blocks from where John Wieland had started his Philadelphia Brewery 145 years earlier.

In Wieland's day, South Park, a block from 21A, was one of the most fashionable residential areas in San Francisco. In the twentieth century, it gradually became an undesirable residential area surrounded by industry. Like most urban industrial areas, the whole South Park neighborhood declined and then decayed as the industry moved to areas far away with more elbow room and a less hostile business climate. By Freccia and O'Sullivan's time, the neighborhood was a quiet place, devoid of reasons to visit and waiting for a reason to enjoy a revival.

This came in Y2K with the opening, less than three blocks to the south, of Pacific Bell Park—the new home of the San Francisco Giants of the National League. Within a few years, a tide of new, high-end and high-rise residential development swept through the neighborhood, and 21A found itself in the center of a vibrant neighborhood. Even as mergers and acquisitions within the telecom industry saw the name of the ballpark change, first to SBC Park, then AT&T Park in 2006, it was hailed as one of the best parks in major-league baseball. It soon became a popular destination for a new generation of fans. In turn, the flood of fans discovered 21A, and it was celebrated by the San Francisco media with such accolades as "Best Brewpub" and "Best Happy Hour."

Over time, Freccia and O'Sullivan decided to expand into production brewing for wider distribution. Because their existing capacity at Second Street was too small, they made the trip to Cold Spring, Minnesota, in 2008 to enter into a contract brewing arrangement with the Cold Spring Brewing Company. Founded in 1874, the Cold Spring brewery had earned an admittedly well-deserved reputation during the twentieth century for having embraced the idea of inexpensive ingredients and very flavor-neutral beer. By the twenty-first century, however, new management under new owner John Lenore began reinventing Cold Spring by installing state-of-the-art equipment in the 170,000-square-foot production facility.

As Doug DeGeest, the general manager, told *Twin Cities Business* magazine in 2013, "We were an old brewery known to make kind of crappy beer. We were at a low point in the industry and knew we had a lot of work to do to change consumers' perception."

Part of the reinvention came in the form of a contract with companies such as the Monster Beverage Corporation to produce energy drinks; another part came in contract brewing of high-margin craft beers.

This is where 21A entered the picture. The volume of beer being produced for 21A at Cold Spring increased tenfold between 2008 and 2010 to 10,000 barrels annually. By 2015, it would expand tenfold again, this time reaching 104,000 barrels. The Second Street brewery continues to be an important element in the 21A strategy, brewing beer for onsite consumption and serving as a "test kitchen," the place where, as O'Sullivan tells it, new products "find their legs."

The Cold Spring operation made it possible for 21A to begin packaging for wider distribution, which began on the West Coast and soon took root in the East—where New Jersey emerged as the second-largest state for 21A beer after California. The 21A beers went onto shelves in around thirty states and became popular in such cities as Chicago and Washington, D.C.

When choosing the form in which its beer would be distributed, 21A became one of the first craft brewers to package its beer in cans. Long considered low-brow among serious beer aficionados, beer cans were suddenly cool again thanks to Freccia and O'Sullivan—as well as the brewers at larger craft operations such as Sierra Nevada and New Belgium, who had also begun canning around this time.

In fact, there are advantages that canning has over bottling. The cans preserve the flavor by preventing exposure to air and natural light. Bottles screen out light by being green or brown, but aluminum is opaque. Aluminum is also lighter than glass and, therefore, lowers freight costs. This opened a

door into the skies for 21A, where airlines prefer cans over bottles precisely because of weight. Shaun O'Sullivan tells of complaining on social media about the beer selection on Virgin America and winding up in a meeting with Rob Gallagher, the airline's catering and onboard services manager. This led to 21A beers being served aboard Virgin flights.

The 21A arrangement with Cold Spring Brewing, now a craft brewer in its own right under the Third Street Brewhouse name, was never intended to be permanent. Freccia and O'Sullivan had long hoped to have a production brewery of their own in the San Francisco Bay area. After years of planning, they leased a ninety-five-thousand-square-foot plant at 2010 Williams Street in San Leandro that once was used by Kellogg's to make Pop Tarts and Frosted Flakes. Opened in 2015, the new 21A facility was centered on a brewhouse with a one-hundred-barrel, German-engineered GEA (Gesellschaft für Enstaubungsanlangen) system built in Hudson, Wisconsin.

O'Sullivan explained to this author that having the new brewery allowed for the kind of innovation and experimentation on a production scale that was not possible at Second Street, because of its size, or at Cold Spring, because it was someone else's brewery.

He walked this author through the development of Toaster Pastry, an India Style Red Pale Ale with 7.6 percent ABV and 74 IBUs; it was the first all-new beer brewed at the new facility, its name is an obvious homage to the products previously produced there. It began in 2014 in the kitchen at O'Sullivan's home and was first brewed commercially the summer of that year for the Ales for ALS fundraiser. Tweaked several times in the ensuing months, it emerged in September 2015 as Toaster Pastry. A complex beer, it is brewed using crystal, Munich and biscuit malt, with Carafa black malt added for color. In turn, it is hopped with Azacca, Calypso, Chinook, Citra, Mosaic and Simcoe hops.

Among the beers that are produced year-round by 21A for sale across the bar on Second Street or packaged in San Leandro are 7 percent ABV, 70 IBU Brew Free or Die IPA; 6.8 percent, 65 IBU Back in Black Black IPA; and 4.4 percent, 42 IBU Down to Earth Session IPA. Seasonals include 6.2 percent, 38 IBU Sneak Attack Saison; 7.9 percent, 45 IBU Fireside Chat Winter Spiced Ale; and the perennial favorite Hell or High Watermelon Wheat Beer, with 4.9 percent ABV and 17 IBUs.

Also available recently on Second Street was 8.5 percent Imperial Jack ESB (Extra Special Bitter), created by Richard Brewer-Hay at San Francisco's Elizabeth Street Brewery. The story of the latter beer is one of those remarkable tales from brewing lore that begs retelling. Richard

had been brewing an ESB named "Grandpa Jack" in honor of his late grandfather, Jack Newbould, when he and O'Sullivan decided to collaborate on a stronger version at the 21A brewery, renaming it "Imperial Jack." As they explain, "in 2010, we entered it in the international World Beer Cup competition, and it won a gold medal in the Other Strong Ale category." They later traveled to London, where they brewed Imperial Jack with Angelo Scarnera, the head brewer at Brew Wharf. They describe this as "an amazing event for both of us, the chance to brew this beer in London. The idea of bringing the Imperial Jack recipe back to England where Richard's grandfather spent his life was a real emotional journey for Richard, one that will be cherished for a lifetime."

AT THE TURN OF THE twenty-first century, at the same time that ThirstyBear, Speakeasy, Beach Chalet, Magnolia and 21A were finding their footing, earning their customers and beginning to make names for themselves, there were several members of the second generation of San Francisco craft breweries that did not make it.

The Potrero Brewing Company opened in 1999 at 535 Florida Street near Nineteenth Street but closed in 2002. In their farewell statement, the owners commented, "The brewery was an ambitious undertaking but we made some early mistakes and were never able to turn it around but we believe we made a great space out of a drafty, concrete hulk of a building and in it, we made the best beers anywhere!"

Another turn-of-the-century operation that did not survive was opened by the Eugene, Oregon–based Steelhead Brewing Company in the Anchorage shopping center near Fisherman's Wharf. It was present only briefly, but Steelhead established a second Bay Area location in Burlingame, south of San Francisco, that remains open.

The birthplace of a beer brand that now contract brews all of its production outside the city is the Pizza Orgasmica & Brewing Company, a vivid yellow Brazilian restaurant and pizzeria at 823 Clement Street and Ninth Avenue.

"Once, there was a successful pizza restaurant owner in San Francisco," writes Taylor Maia autobiographically.

> *He had come a very long way from his home in a small town in central Brazil and made his dream of opening a place to create and serve his Orgasmica Pizza a reality. He met and married a wonderful woman* [named Gina Gochez] *and together they opened a second, far*

larger restaurant. Still, there was something missing. "What goes best with pizza?" he thought. "Beer!" Well, what would go best with Orgasmica Pizza? Orgasmica Beer of course!

After Orgasmica Peach Pale Ale and Orgasmica Raspberry Hefeweizen first went on tap in August 2004, they were joined by other beers, which are brewed at Devil's Canyon Brewing Company in San Carlos, south of San Francisco.

In 1997, meanwhile, Jeff and John Figone opened their Golden Gate Park Brewery at 1326 Ninth Avenue in the Sunset District, exactly one mile as the crow flies, due south of Orgasmica. Their operation survived only until 1998, but it was only the first of a series of craft breweries to be active at

The Social Kitchen & Brewery, which bills itself at "the Sunset's Local," is the fourth brewery restaurant to operate at this location on Ninth Avenue near Irving Street. *Bill Yenne photo.*

that location. After the Golden Gate Park Brewery closed, Eldo's Grill and Microbrewery operated at 1326 Ninth Avenue until 2007.

Shortly thereafter, the Ninth Avenue space was taken over by Wunder Brewing, the new operation named for brewmaster John Wunder, a fermentation science graduate of the brewing program at the University of California in Davis—with a reference to San Francisco's original Wunder Brewing Company that closed in North Beach in 1909 after the Earthquake and from which the new Wunder borrowed its logo. This second incarnation of Wunder Brewing was short-lived, closing in 2008.

In 2010, the Social Kitchen & Brewery became the fourth brewery to operate at 1326 Ninth Avenue. Heading the brewing program at Social Kitchen was veteran brewer Rich Higgins, who had started his career in 2004 as an assistant brewer at the San Francisco Brewing Company. In 2005, he had moved to Gorgon Biersch and, later, to ThirstyBear before taking over as the original brewmaster for Social Kitchen. In this role, his most famous creation was his Big Lebowski White Prussian, first brewed for Strong Beer Social 2011. It was inspired, he says, by the White Russian cocktails favored by the lead character, portrayed by Jeff Bridges, in the 1998 cult classic film *The Big Lebowski*. In turn, he spun the name Germanically, and the White Prussian was born. Made with smoked, coffee-roasted malts, it has an IBU rating around 15 and is greater than 9 percent ABV.

He writes:

> *It quickly became my most popular and cult-iest beer. It's two beverages in one—on one hand, it's a nerdy, esoteric beer style re-envisioned as a contemporary strong beer, an "imperialized" grätzer (a Prussian smoked, sour beer; grodziskie in Polish). On the other hand, it's my attempt to redeem a fairly ridiculous (but sinfully delicious) cocktail by capturing its essence in really tasty beer. And if you have a Big Lebowski in both hands, you've got the beginnings of a quite a night.*

Higgins continued at Social Kitchen until 2012, when he handed the reins over to Kim Sturdavant, a veteran of more than five years across the Golden Gate Bridge at the Marin Brewing Company.

By this time, Higgins had fleshed out his résumé with a variety of posts within the San Francisco Brewers Guild, including serving in the presidency, and had become one of fewer than a dozen people in the Bay Area to be certified by the Craft Beer Institute as a master

cicerone, meaning that he possessed an "encyclopedic knowledge of beer and highly refined tasting ability." Armed with this, he began life as an industry consultant and lecturer.

The current lineup at Social Kitchen includes 4.7 percent ABV SKB Pils, 5.6 percent Cas Wak Pale Ale and 5.7 percent Mr. Kite's Pale Ale.

By the end of the first decade of the twenty-first century, the members of the second generation of San Francisco craft breweries who had survived their initial growing pains and had become established, each in its own niche. From Speakeasy as a production brewery with growing output and a growing national profile to ThirstyBear and Beach Chalet as brewery-restaurants with loyal followings and prominence in the tourist trade to 21st Amendment, a hybrid of the two, the breweries of the second generation were now integral not only to the San Francisco brewing scene but also to the civic life and culture of the city.

The story was about to move on to the next chapter as a third generation embraced another wave of new brewing companies and new types of brewing entities became defined by a new vocabulary of terminology.

INTO THE FUTURE

B ack in the mid-nineteenth century, even as the Gold Rush was changing the course of San Francisco and California history, the city was rapidly becoming a rich tapestry of small breweries, alive with the crackling ingenuity and creativity of brewing entrepreneurs.

In the twentieth century, starting with the dual darknesses of the Earthquake and Prohibition, the landscape changed. The smaller breweries withered and died, while the midsized breweries expanded rapidly and found themselves forced to literally water down their beer in order to compete with the national brands for price point and shelf space.

With the twentieth century nearly spent, there was a murmuring of a revival of a delicious past as Fritz Maytag saved a brewery and created a legend and as Allan G. Paul opened his doors a block from where the metaphorical ghost of Francis G. Hoen held court. By the turn of the twenty-first century, San Francisco was *once again* rapidly becoming a rich tapestry of small breweries, once again alive with the crackling ingenuity and creativity of brewing entrepreneurs.

In the middle of the second decade of the twenty-first century, even as this book was being written, more new commercial breweries were opening their doors than had done so during all of the twentieth century since the ashes of the 1906 Earthquake still burned one's nostrils. It has been and is an exciting time to be a beer lover in the Golden Gate City.

The largest new brewery to open in San Francisco in about a decade was the Southern Pacific Brewing Company, which was brought on the scene

The Southern Pacific Brewing Company opened in 2012 across the street from the site of the Pacific Brewing & Malting 1916 refugee brewery and around the corner from where Jacob Adams had moved the Broadway Brewery in 1895. *Bill Yenne photo.*

in 2012 by San Francisco native Chris Lawrence. A full-service brewery-restaurant, it is located in a ten-thousand-square-foot former machine shop at 620 Treat Avenue near Nineteenth Street in a block with a great deal of brewing history. The new Southern Pacific is practically across the street from 675–77 Treat, the site where Carlton Huth of Tacoma's Pacific Brewing & Malting had built his refugee brewery in San Francisco in 1916 when Prohibition came to Washington and where Regal brand beers were still being brewed in the 1950s. It was also just around the corner, within the same block as the 3151–91 Nineteenth Street location, to which Jacob Adams (aka Johanas Adami) had moved the Broadway Brewery in 1895.

Southern Pacific took its name from the railroad that once operated spur lines throughout this industrial part of town, especially on nearby Harrison Street, and that carried Broadway and Regal beer, among other cargo. The Southern Pacific Railroad had been based in San Francisco and was the largest railroad company in the West. It was one of San Francisco's leading companies for more than a century, until it was absorbed by a succession of other roads in the late twentieth century.

With brewing under the direction of Andy French, the fifteen-barrel brewhouse turns out what Southern Pacific calls "clean, dry, true-to-style

beers." Among these are 5 percent ABV, 10 IBU Hefeweizen; 5.5 percent, 22 IBU Kölsch; 5.2 percent, 35 IBU California Blonde; 5.4 percent, 42 IBU Pale Ale; 5.8 percent, 55 IBU India Pale Ale; and 6 percent, 28 IBU Porter. A variety of guest beers is also offered on a rotating basis for restaurant-goers.

AT THE OPPOSITE END of the square footage scale from Southern Pacific, a new crop of vastly smaller new breweries came on the scene—along with new terminology to describe them. The late twentieth century saw a craft brewing revolution that was manifest in microbreweries, brewpubs and, eventually, full-service brewery-restaurants. In the twenty-first century, the new word was "nanobrewery," a term that was even adopted by the U.S. Department of the Treasury as part of its business definitions for taxation purposes. The term describes breweries that are much smaller than microscopic—analogous to the phrase "vest pocket brewery," coined by Klaus Lange in 1987. The root word "nano" is a scientific term meaning one billionth and, therefore, very small. In the metric system, a nanometer is the width of three gold atoms, or how long a fingernail grows in a second. In fact, nanobreweries are on the scale of the original microbreweries of the 1980s that operated before the definition of a microbrewery increased from being a brewery with an annual output of less than three thousand barrels to less than fifteen thousand.

One of the earliest examples of a place in San Francisco that carried the nanobrewery label was the tiny Cervecería MateVeza opened by Jim Woods at 3801 Eighteenth Street at Church Street, across the street from Dolores Park, in 2012. His original beer was MateVeza Yerba Mate, a 7 percent ABV IPA, the first beer in the world made with yerba mate, the traditional green tea of Argentina that was decried by sixteenth-century missionaries for its alleged addictive properties. Originally, this beer was contract brewed in Ukiah by Mendocino Brewing, but Woods was anxious to find a space in San Francisco where he could brew and serve on site and indulge his passion for small-batch beers.

As Woods explains, the twenty-gallon brewing system at his facility on Eighteenth Street allows him to "take risks" with innovative recipes and to brew something new and interesting every week as the mood strikes him. As he puts it: "We brew small batches of fresh, exciting, and experimental beers, often in collaboration with our friends in the Bay Area's vibrant food and drink world."

Though MateVeza has developed a cult following and is regularly on tap, most of the handles at Cervecería are unique selections. Estimating that two-

Above: The interior of the bar at Jim Woods's Cervecería MateVeza on Eighteenth Street. *Courtesy of the Woods Beer Company.*

Left: Cervecería MateVeza is located just across the street from Dolores Park, a popular gathering place for residents of the central part of San Francisco. *Bill Yenne photo.*

thirds of his beers are produced fewer than three times, he shuns the idea of becoming a production brewery. He finds it "more fulfilling professionally and personally" to continue brewing small batches.

This has not stopped him from expanding to additional locations under the banner of the Woods Beer Company. He first opened another bar, the Polk Station, at 2255 Polk Street and then a second brewpub location, the Woods Bar and Brewery, which opened in Oakland in 2014. There is nothing "nano" about the geographic scope of the Woods Beer Company locations.

Another term born into the lexicon of craft brewing in the twenty-first century is "gypsy brewer," a brewer who has no specific location but rents time and space from existing, licensed breweries to brew beer for commercial sale. A related concept is that of the "guest brewer," who brews at larger facilities as a guest.

As with most things about craft brewing, the gypsy business model was born on the West Coast before there was a word to describe it. It spread east—where the trend was "discovered" by the national media—and ultimately to Europe. Indeed, the world's most famous gypsy brewery—thanks to tireless public relations—is probably Copenhagen-based Mikkeller. The story was brought full circle in 2013 when Mikkeller opened its first non-European beer bar in San Francisco. Brewing in the United States, and at a fixed site, began for Mikkeller in 2015 in San Diego at a facility previously used by the AleSmith Brewing Company before its move to larger quarters.

In the Bay Area, examples of gypsy brewers include Phil Cutti and Patrick Horn, whose Headlands Brewing Company is based in Mill Valley, a half hour north of San Francisco, but who brew at locations in the city. Cutti, who had been associated with Mill Valley Beerworks and other entities, also served as the head brewer at Southpaw BBQ, a San Francisco nanobrewery-restaurant that opened in late 2011 at 2170 Mission Street with a seven-barrel brewing system tucked behind the bar. Located a few blocks on the other side of Dolores Park from Cervecería MateVeza, Southpaw was the brainchild of Alabama native Elizabeth Wells, who recalls that she "learned at an early age that you don't sass your parents, you always say a kind hello to strangers and there are absolutely no shortcuts in good Southern cooking."

She adds, "Nothing quite goes better with Southern BBQ than a cold pint of beer and whiskey. So when old friends from the South decided it was time to open a restaurant that authentically reflected the food they had grownup with, brewing their own beer just seemed to be the perfect pairing." As she told this author, she feels that beer and barbecue "bring people together," and she is pleased to have created a community in which this can take place.

Brewer Ross Halligan and owner Elizabeth Wells at Southpaw BBQ and Southern Cooking on Mission Street, a nanobrewery restaurant that was started by Elizabeth in 2011. *Bill Yenne photo.*

Though the selections behind the handles change frequently and include a majority of guest beers, the offerings from the brew kettle behind the bar include four or five from the Southpaw kettle. Among these are 5.7 percent ABV Pale Ale, 6 percent Sour Brown Ale and 5 percent Big Bad Leroy Brown.

Another gypsy partnership is that of former home brewers Jesse Friedman and Damian Fagan, who started their Almanac Beer Company in 2010. With offices in San Francisco, they brew outside the city, originally at Drake's Brewing Company, across the bay in San Leandro. On the company's website, Friedman and Fagan note:

> *Using farmer's markets as the launching pad for many unique homebrews, we knew right away we were on to something…We've taken that passion and adventurous spirit and decided to brew on a larger scale with the hope of sharing our vision with our community. Each harvest we partner with a different Northern California farm to*

supply the fruit used for our next brew. Every beer is a collaboration between us and the local terroir.

The Pine Street Brewery, meanwhile, is a self-described "collective" that evolved from homebrewing in a small apartment on Pine Street, but the group has moved several times. Notable among its subsequent venues was the Bourne Mansion on Webster Street in Pacific Heights, which was designed by Willis Polk, the same man who designed and built the Beach Chalet in 1896 for millionaire William Bourne.

Perhaps the best known of those entities that are on the cusp of becoming part of a future generation of San Francisco commercial breweries is the Elizabeth Street Brewery. Located on the street of the same name in Noe Valley, in the geographic center of San Francisco, it is essentially a converted storage space in the basement of the home of Alyson and Richard Brewer-Hay. Richard started brewing in 2003 on the back deck of his home and noticed that neighbors would continually drop in to learn about the process and sample his wares. He applied his professional social media skills to his hobby and word of the "homebrew-pub" spread. The Brewer-Hays have had tourists appear at their front

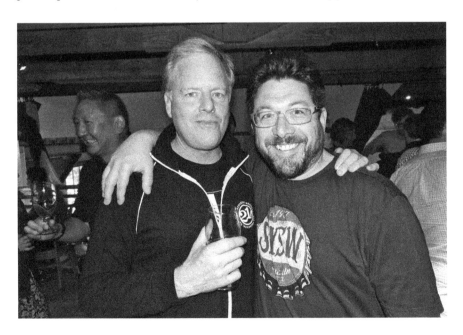

Shaun O'Sullivan of the 21st Amendment Brewery (left) enjoys a lighter moment with Richard Brewer-Hay of the Elizabeth Street Brewery. *Bill Yenne photo.*

door from all over the world hoping to get a glimpse of the infamous, not-so-secret speakeasy. The "ESB" is a true family operation. All beers are named after family members—from Daddy's Chocolate Milk (a stout) to Mummy's Double Honey (an ale). Then, too, there are the Imperial Jack ESB, named for Richard's late grandfather, and the Extra Special Bitter that he brewed with Shaun O'Sullivan at the 21st Amendment Brewery and that earned him a gold medal at the World Beer Cup competition.

Alyson and Richard both brew together, and their two elementary school–aged daughters, Addison and Quincy, make their own vanilla root beer. As an unlicensed homebrewery, the Brewer-Hays have never sold a single drop of their beer from the Elizabeth Street location, but this only adds to the mystique. Noting that there is an LLC in place and that their trademarked logo is visible on hats and shirts worn by fans far and wide, Richard promises, "The next phase of the Brewer-Hay beer odyssey is not far away."

SOUTH OF MARKET, IN an area that was once the home of half or more of San Francisco's breweries, there had been no new commercial breweries west of ThirstyBear since Twenty Tank closed in 2000. The Cellarmaker Brewing Company opened its doors as a brewpub in 2013 at 1150 Howard Street between Seventh and Eighth Streets. Cellarmaker was a partnership of three proprietors. Coloradoan Connor Casey had worked previously for the Marin Brewing Company and City Beer Store. Tim Sciascia, Cellarmaker's head brewer, graduated from the New England Music Conservatory with a major in classical saxophone and had worked for the Boston Beer Company (makers of Samuel Adams), though not as a brewer, before heading west. Here, he worked for several years brewing at Marin Brewing. Kelly Caveney, whom Cellarmaker describes as the "tasting room and operations manager aka head cellar maiden," is a veteran of the bars at both Marin Brewing Company and the Russian River Brewing Company.

The approach of the Cellarmaker team is as assertive as their hop-forward beers. "We are a San Francisco brewery producing small batches of experimental beers," they point out. "It is our goal to keep your taste buds intrigued by constantly producing different flavors. To us, making the same three to four beers all the time would be boring in many ways…Our limited output and choice to abandon the common concept of a set production schedule (and flagship beers) will allow us to constantly experiment with different hops, grains, barrels, and yeasts."

Right: The Cellarmaker Brewing Company on Howard Street was started in 2013 by Connor Casey, Tim Sciascia and Kelly Caveney. *Bill Yenne photo.*

Below: San Francisco beer aficionados J.R. Hubbard (foreground) and Mike Bolos give some serious attention to the current selections in the beer list posted on the wall at Cellarmaker. *Bill Yenne photo.*

A recent example was Cellarmaker's Dank Statement Triple IPA, with 9.8 percent ABV and 90 IBUs. The company said, "This beer is packed with 70 pounds of hops in one batch—almost three times as much as a batch of regular IPA—Simcoe, Citra, CTZ, Amarillo and Centennial." In addition to the constantly changing rotation at Howard Street, Cellarmaker distributes to around two dozen other bars, mainly nearby. With Cellarmaker, it is rare to find the same beer twice, though we have noticed some that do recur from time to time.

Among the members of the newest generation of San Francisco commercial brewers are former gypsy brewers who stopped traveling to set up shop at fixed locations in what would be called brick-and-mortar buildings if San Francisco were not in earthquake country where brick-and-mortar construction does not meet building codes.

In 2014, the Triple Voodoo Brewery found a home at 2245 Third Street in the heart of Dogpatch, two blocks from where Dave McLean was opening his second Magnolia location. Along with his partners, Greg Kitchen, who had been a gypsy since 2011, took up residence in what was described as "a spacious modern industrial themed brewery and tap room featuring 16 rotating taps."

Unlike its neighbors up the street at Smokestack, Triple Voodoo is neither a brewpub nor a restaurant. It offers only beer in its taproom while encouraging patrons to order food for delivery from many of the local eateries that have sprung up across Dogpatch.

Brewing is done on an all-new, thirty-barrel system from Portland Kettle Works. As Kitchen told this author, he had considered buying preowned gear, but he wanted to be "in the business of brewing beer, not in the business of repairing brewing equipment."

As with many twenty-first-century craft breweries, the beer brewed at Triple Voodoo rotates frequently, though the company's first beer, 8 percent ABV Inception Belgian Style Ale, remains a popular staple.

Kitchen goes on to describe his interest in brewing complex beers, "beers that you can cellar," and speaks of beer and food pairings. When this author stopped by, he had a beer and cheese pairing event on the schedule and was talking of a beer and chocolate event.

As for the "Triple Voodoo" name, Greg Kitchen explained to the CraftBeer.com blog in 2013 that it

represents the vision of our founding partners and our three unwavering principles: a passion for creating the extraordinary, a desire to share those

The Triple Voodoo Brewery, which opened on Third Street in 2014, was the second craft brewery to open in the Dogpatch neighborhood. Brewing was under the direction of Greg Kitchen, formerly a gypsy brewer. *Bill Yenne photo.*

creations with the world, and an ultimate goal to help make the world a better place for everyone. "Voodoo" comes from our passion for conjuring magic in a glass and our fascination with the mysterious and the misunderstood brewing process.

Joining Magnolia and Triple Voodoo as the third new brewery in the increasingly vibrant Dogpatch was the Harmonic Brewing Company, which opened at 1050 Twenty-sixth Street in August 2015. Founded by Ed Gobbo and Jon Verna, Harmonic is a nondescript former warehouse on the outside,

The rotating selection of beers available at Triple Voodoo often includes Inception Belgian Style Ale. *Bill Yenne photo.*

but inside, the warehouse space gave them over 1,000 square feet of brewery space and 1,400 square feet for a taproom.

As Verna told Scott Mansfield of *7X7 Magazine*, "The ale we're most excited about is our flagship Rye Old Fashioned Pale, a nod to the classic American cocktail, rye malt gives it a slightly spicy backbone. Cascade and Amarillo hops provide bitterness and brightness and enhance the citrus aromatics. The result is distinct and very drinkable, like a well-crafted cocktail."

In addition to 5.3 percent ABV Rye Old-Fashioned, other beers that were on tap as Harmonic opened included 5.4 percent ABV Batch 1 IPA, 5.9 percent Northwest Pale and 4.8 percent Cold-Press Stout, served with nitrogen.

Farther north, but south of Market in SOMA, where Cellarmaker had debuted in 2013, others were now arriving. The Local Brewing Company was opened with a ten-barrel brewhouse at 69 Bluxome Street in 2015 by Sarah Fenson and Regan Long, who had been San Francisco gypsy brewers since 2010. After gaining a following through a free distribution of

The Harmonic Brewing Company was opened in 2015 on Twenty-sixth Street in Dogpatch by Ed Gobbo and Jon Verna. *Bill Yenne photo.*

When the Local Brewing Company opened on Bluxome Street in 2015, owners Sarah Fenson and Regan Long already had five years of experience as gypsy brewers. *Bill Yenne photo.*

their wares in Dolores Park, their first commercial offering was their 1776 India Black Ale (IBA), which has 7.8 percent ABV and 75 IBUs. This was followed by their 7.8 percent, 67 IBU Angel Island India Red Ale (IRA). Next came 5 percent ABV Bluxome Black Lager, with 20 IBUs, which earned an award at the 2015 California State Fair.

Another new SOMA brewery that opened in 2015 with roots in the Bay Area brewing scene is Black Hammer Brewing at 544 Bryant Street, near Third Street. It is a collaboration between chemical engineer Jim Furman—a veteran of Pete Slosberg's Pete's Brewing Company, the Palo

Black Hammer Brewing, which opened its doors on Bryant Street in 2015, was the creation of two engineers, Jim Furman and Bryan Hermannsson, whose Pacific Brewing Laboratory was an earlier, high-profile homebrewing operation. The Pacific Brew Lab "squid" logo is visible in the sign on the right. *Bill Yenne photo.*

Alto originator of Pete's Wicked Ale—and biomedical engineer Bryan Hermannsson of Pacific Brewing Laboratory. Hermannsson and Pacific Brew Lab had been a fixture on the SOMA brewing scene since 2011, when he and Patrick Horn started giving away their creations out of their garage at 214 Clara Street, about three blocks west of the Black Hammer location. Horn, as noted previously, is a partner, along with Phil Cutti, in the Headlands Brewing Company.

As Furman, the Black Hammer co-owner with K. Albert Jackey, told Angeline Ubaldo of *Hoodline* in August 2015, the focus at the brewery would be on English ales and German lagers as a "counterpoint to the hop-crazed culture" of many craft breweries, aiming to create malt-forward beers "where your palate is not wrecked, it's enhanced."

Black Hammer Brewing features popular, 7 percent ABV, 54 IBU Squid Ink India Black Ale, which led Hermannsson's portfolio for years (the Pacific Brew Lab logo is a squid). Other offerings include 5.1 percent, 18 IBU Nautilus Hibiscus Saison and 9.8 percent, 88 IBU Whipnose Imperial IPA.

The story behind the Black Hammer name begins with "Hammer," a nickname that Furman picked up at the annual Burning Man event in the Nevada desert, to which he added a reference to Black Rock City, the temporary "city" that is the venue for Burning Man.

Bartlett Hall on O'Farrell Street north of Market Street opened in 2014 as the first new brewery restaurant to operate in the vicinity of Union Square in about a decade. It is named for Washington Allon Bartlett, the man who named San Francisco back in 1847. *Bill Yenne photo.*

North of Market Street, on the opposite side of Union Square from where E&O and Café Pacifica came and went a decade earlier, Bartlett Hall opened at 242 O'Farrell in May 2014 with Christopher Wike as brewmaster. Noted for its sports bar ambience, Bartlett Hall reaches into San Francisco history to take its name from the first of two men named Washington Bartlett to have served as mayor of San Francisco—though when this man, Washington Allon Bartlett, assumed the post in 1846, he did so under the Spanish title *alcalde*. He is also remembered as the man who, in 1847, changed the name of the village of Yerba Buena to San Francisco.

In July 2015, on the western shoulder of Bernal Heights, the Old Bus Tavern was opened at 3193 Mission Street by Bennett Buchanan,

Top: Brewmaster John Zirinsky was one of the founding partners at the Old Bus Tavern, which opened on outer Mission Street in 2015. *Bill Yenne photo.*

Right: The draft list at the Old Bus Tavern includes beers brewed by John Zirinsky in his little brewhouse about ten feet away, as well as guest beers from San Francisco and beyond. *Bill Yenne photo.*

Jimmy Simpson and John Zirinsky, who wanted to operate a neighborhood brewpub. Old Bus was named not for the myriad bus lines that have plied the Mission Street corridor through the decades but for Zirinsky's 1978 Volkswagen Westfalia, in which he, his wife and his dog cruised the highways and byways of the United States before settling in California.

When this author paid a call on Zirinsky shortly after Old Bus opened, he was at work on his four-barrel Portland Kettle Works system and proud to show off an extensive steam system installed by Leo Gotelli of Brisbane, who had also done the plumbing at the Speakeasy Brewery. Three tankless hot water heaters, in turn, efficiently supply unlimited hot water.

The California Cluster hops that he was using that day were from Union Hops in Yuba City. This illustrates a growing trend among craft brewers who are using more and more California hops grown in regions that were once the major supplier for the state's brewing industry. After many decades with little or no hop cultivation in Northern California, the trend is changing.

Zirinsky explains that, although he likes experimentation, his brewing philosophy is directed toward creating approachable, rather than extreme, beers, adding that he is "not aiming for a flagship beer." Among those on tap at the beginning were 5.5 percent ABV Lemon Basil Saison, 5.5 percent Rye So Serious? Pale Ale, 6 percent Lemon Drop Session IPA and Texas Breakfast Chili Porter, the latter served with nitrogen.

At the end of 2015, San Francisco's southernmost brewery opened at 1439 Egbert Avenue in the Bayview District, practically within sight of the huge and imposing building that was the home of General Brewing and Lucky Lager from 1934 to 1978. Laughing Monk Brewing is the creation of Andrew Casteel and Aaron Hicks, two homebrewers with an interest in Belgian-style beers. The massive murals decorating the interior walls of the brewpub at Laughing Monk were painted by noted muralist Shawn Bullen, with whom Casteel and Hicks had partnered in the Imprint.City organization, whose objective was to produce murals throughout the Bayview area.

The first beer produced commercially at Laughing Monk was 5.8 percent ABV, 28 IBU Sunshine Saison, brewed with chamomile. Other selections include 9 percent Evening Vespers, 9 percent Cherry Bough and 16 percent Devil's Hoard.

It was also in 2015 that the Black Sands Brewery opened at 701 Haight Street, near Pierce Street, in the Lower Haight. The location was two blocks from the Toronado at 547 Haight, which has been San Francisco's quintessential beer bar since Dave Keene opened his doors in the 1980s. Black Sands is the creation of brewers Cole Emde and Andy Gilliland, along with restaurateur

Right: The Black Sands Brewery was opened on Haight Street in 2015 by Cole Emde, Andy Gilliland and restaurateur Robert Patterson. *Bill Yenne photo.*

Below: "Learn to Make Beer" reads the A-frame sign at Black Sands. In addition to being a brewery restaurant, Black Sands operates a homebrew supply shop in a garage (left) immediately adjacent to its brewery (behind the roll-up door in the right). "Our supply store is a place for beginners and experienced home brewers to get everything they need to make beer," it explains on its website. "We are here for questions, advice, or just to have a beer with and talk homebrew." *Bill Yenne photo.*

Robert Patterson, who is known in the San Francisco food community for his Mission District eatery Ken Ken Ramen.

Black Sands is both a brewery and a full-service restaurant serving from breakfast to dinner—but there is more to it than this. The owners also note:

> *As a brewery, we are focused on beer and education. Beer is getting complicated these days, and we don't think it has to be. We make our own beer, serve it at our bar, and give the recipes away to homebrewers. If you want to know about our beer, we will literally hand you the recipe. We also operate a homebrew supply store right next to our brewery where you can get all the ingredients and equipment to make our recipes at home yourself. We even teach brewing classes to anyone who wants to get into the hobby of home brewing.*

At the time of the Black Sands opening, Patterson told Scott Mansfield of *7X7 Magazine* that the brewers were "working on a signature series of beers called SMASH, an acronym for Single Malt and Single Hop: One malt type, one hop varietal, yeast, and water."

About a dozen blocks north and west of the Lower Haight, the Barrel Head Brewhouse is a 150-seat brewery-restaurant that was opened in March 2014 in a long-abandoned building at 1785 Fulton Street by self-described "refugees of the fine dining world," including owner and brewmaster Ivan Hopkinson and head chef Tim Tattan. Hopkinson's fifteen-barrel Prospero brewhouse generates a wide range of beers, which flow into a pair of fifteen-barrel fermenters and three fifteen-barrel bright tanks that serve the bar.

The centerpiece of this bar is a replica torpedo fitted with forty-two tap handles that is one of the big attractions for first-time patrons of Barrel Head. As Hopkinson told Paolo Lucchesi of *SFGate*, his father had been a U.S. Marine Corps fighter pilot, and he had intended to pay tribute to his trade by using a deactivated AIM-9 Sidewinder air-to-air missile. However, its diameter was too narrow, so he commissioned local artists Sam Ferguson and Dave Huebner to build the facsimile torpedo as a base for his taps. The working propeller is turned by a sewing machine motor.

The majority of the handles are those of guest beers. In turn, these are almost entirely Northern California beers, although Stone Brewing and Ballast Point of San Diego have been seen, as have Belhaven and Morland's from the United Kingdom.

As Hopkinson writes in his page at the San Francisco Brewers Guild site, "Our array of awesome guest beers allows us to brew whatever we are

The Barrel Head Brewhouse was opened on Fulton Street in 2014, with brewing under the direction of Ivan Hopkinson. *Bill Yenne photo.*

inspired to make on any given brew day. We enjoy experimentation and also trying to nail classic styles. We like to keep our regulars on their toes by constantly brewing new innovative beers encompassing the spectrum of malty, hoppy, and weird."

He goes on to reference, among others, his 6.3 percent ABV Black Kölsch, 5.6 percent Silence Dogwood Colonial Porter and 6.5 percent Fresh Squozed Wet Hop IPA. Additional offerings have included 6 percent Faderade Framboise, made with fresh Watsonville raspberries; 6 percent Ichabod's Cane,

with Corralitos, that is served on a nitrogen tap; and the interesting 7 percent She Wolf Strawberry Gose.

In 2015, Sunset Reservoir Brewing opened as a brewery-restaurant at 1735 Noriega Street near Twenty-fourth Avenue, about a block from its eleven-acre subterranean namesake. Located in a six-thousand-square-foot former grocery store, Sunset Reservoir was started by Hilary Cherniss, the owner of the Devil's Teeth Baking Company at 3876 Noriega Street, a bakery that is named for the nickname of the rugged Farallon Islands, which are located thirty miles offshore of San Francisco and visible—on a clear day—from the Sunset District.

As brewmaster, Cherniss hired Aaron Weshnak, late of the Russian River Brewing Company in Santa Rosa. Among the beers in the early Sunset Reservoir lineup were 5.9 percent ABV Extra Pale Ale, 6 percent Maibock and Sour Wheat, a wheat beer made with sourdough bread starter from Devil's Teeth.

Barely half a mile from the San Francisco anchorage of the Golden Gate Bridge, the Fort Point Beer Company was started in late 2014 as a production brewery. The founders of Fort Point were the brothers Justin and Tyler Catalana, owners of Mill Valley Beerworks, a brewpub located across the bridge in Marin County.

Located at 644 Old Mason Street inside the Presidio of San Francisco, the brewery took its name from the 1861 brick fortress that lies directly beneath the bridge. Given that the brewery is located on federal property that is administered by the National Park Service, Fort Point cannot sell beer on its premises, but within its first year, it had established an impressive network of bars and retail locations, including around four hundred in San Francisco and more than one hundred in the East Bay. In August 2015, the brewery announced the opening of its own retail location at the Ferry Building Marketplace, a specialty food destination in downtown San Francisco.

The products brewed at Fort Point are described as "balanced, thoughtful beers that reference traditional styles but are by no means bound to them. Those leading the lineup in the early months were 4.7 percent ABV, 19 IBU Park, a wheat beer made with *bière de garde* yeast supplements and hopped with Citra; 5.6 percent, 16 IBU Westfalia Nuremburg red ale, described as "a malt purist's dream"; and KSA, which Fort Point calls "an idiosyncratic take on the classic kölsch style," at 4.6 percent with 17 IBUs. As head brewer Mike Schnebeck, a longtime veteran of the three-barrel nanobrewery at Mill Valley Beerworks, explained to this author, he is "happy to brew everyday beers."

The delivery van of the Fort Point Beer Company gets plenty of use as the brewery has tap handles in around four hundred locations in San Francisco alone. *Bill Yenne photo.*

The forty-gallon brewhouse at the Fort Point Beer Company inside the Presidio of San Francisco, just a short distance for the actual Fort Point. *Bill Yenne photo.*

WHILE LOOKING AHEAD INTO the world of San Francisco brewing in the second decade of the century, the author caught up with Master Cicerone Rich Higgins, the former brewmaster at the Social Kitchen & Brewery who had become a consultant on a variety of topics from brewing to system design to food pairings at restaurants and breweries throughout San Francisco. Among the projects he was bringing on line were the brewing operations at the Bon Marché Brasserie & Bar at 1355 Market Street in the Twitter Building and Citizen Fox, a vegan restaurant on Mission Street that is the brainchild of veteran restaurateur Deborah Blum.

Explaining that Bon Marché is inspired by the *brasseries* of Paris, Higgins is quick to remind us that the French word *brasserie* actually means "brewery" and that it is only in the vernacular that it has become synonymous with "bistro." At last putting a brewery into a *brasserie*, Higgins brews on a steam-fired, seven-barrel system from Portland Kettle Works that he would turn over to a permanent brewmaster at the end of his consulting tenure. In the meantime, he has created a beer list for Bon Marché that includes three categories of beer—"ones that you would be likely to find at a typical Paris *brasserie*, ones that you *should* find at a Paris *brasserie*, and IPA." The latter was chosen because of the popularity of that style in the San Francisco beer world of today. Among the "should find" beers, Higgins included Anchor Porter, which he feels to be an excellent pairing companion for French bistro food. The beers he designed for brewing on site include his *bière de garde*, known as L'Ouvrier, and Sur Lie, a pilsner made with French hops and malt. At Citizen Fox, a seven-barrel, direct fire from Premier Stainless of San Diego allows him to indulge his interest in exploring the "intrigue" of malt flavor profiles.

Higgins also speaks of his "infatuation with the flavor contributions made by the yeast during fermentation." With this in mind, he explains that he does not think of his yeast as an ingredient but almost as a collaborator and that his role in fermentation is "to babysit my yeast," adding that he would "never think I'm in charge."

In reflecting on San Francisco craft brewing in the twenty-first century, we think of the intense interest that brewers take in the subtleties of the nearly countless varieties of hops and malt that are available to them and the infinite combinations of the two. Added to this, we think of Rich Higgins and his "infatuation" with the flavor contributions made by yeast and are reminded that craft brewers have embraced not only yeast of the genus *saccharomyces*, the brewer's yeast of their predecessors, but also of the genus *brettanomyces* and the unique sensory compounds that it produces.

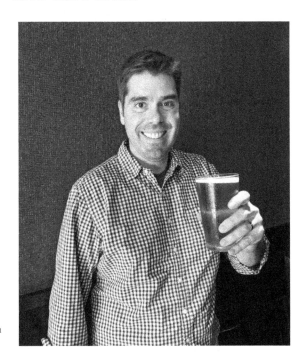

Master Cicerone Rich Higgins began his brewing career at Allan Paul's San Francisco Brewing, went on to serve as brewmaster at the Social Kitchen & Brewery and became a consultant on a variety of topics from brewing to system design to food pairings at restaurants and breweries throughout San Francisco. *Bill Yenne photo.*

We also think back to that comment that was made by Mike Schnebeck at Fort Point about brewing everyday beers, and with it comes to mind not a sense of satisfaction with the ordinary but a succession of other observations. Indeed, in San Francisco, the adjective "everyday," when applied to the beer produced in the city every day, can mean many things—indeed many dozens, if not hundreds of things. The range of styles and nuances in the beer brewed here *every day*, week in and week out, is something beyond the imaginations of those who brewed here just a generation or two ago. When this author first started writing about craft brewing in San Francisco in the 1980s, it was possible to taste every craft beer made in the city in the course of a couple of nights of pub crawling. Today, it would obviously be physically impossible, as new beers are being added faster than one could get through the list. When the San Francisco Brewers Guild organized the first San Francisco Beer Week in 2009, it was possible for one to at least aspire to attend most of the events that were being offered. In recent years, as the number of events being held at pubs, restaurants and breweries over the span of ten days has grown to exceed seven hundred, that, too, has become impossible. Meanwhile, the membership of the guild itself has grown from a half dozen not so long ago to more than two dozen, and the number is increasing almost on a monthly basis.

What does it mean when the choices exceed one's ability to experience them all? It means that the choices are effectively unlimited. Just as it is possible to find an event every day of Beer Week that is to one's liking, it is possible to find a virtually limitless selection of new beers to sample.

What does it mean when the combinations of hops, malts and yeasts available to craft brewers are unlimited? San Francisco has long been a wonderful place to go out and enjoy a beer, and as the brewery scene evolves and grows—with increasing variety, sophistication and attention to detail—things for us on the consumer side will only become better and better.

As we look into the future of San Francisco brewing in the twenty-first century, we turn to San Francisco's oldest brewery. Throughout the twentieth century, Anchor Brewing was a survivor of misfortunes that logically should have consigned it to history, but each time, it survived. A century ago, it should not have risen from the ashes of the 1906 calamity, but it was saved by Joseph Kraus, August Meyer and Henry Tietjen. A half century later, Anchor should not have persevered in the face of the unbearable market pressures of industry consolidation, and it would not have but for the tenacity of Fred Kuh, who would serve nothing else at his Old Spaghetti Factory, and for the timing, vision and stubborn determination of Fritz Maytag.

It was Maytag's vision that saw Anchor embrace myriad innovations and initiatives, from the revival of the idea of Christmas beer to the revival of porter and barleywine to the project in which he recreated a beer from the world's oldest known recipe.

In turn, it was Maytag's vision that led Anchor into distilling in 1993. He took this bold step because of the intellectual, historical and scientific curiosity that is part of who he is. He wanted to create a pot-distilled, American rye whiskey inspired by the earliest eighteenth-century precursors and to do so using 100 percent malted rye—so he did it. At the time, rye whiskey was a rarity and there were no pot-distilled whiskeys being made legally in the United States. What began as an experiment led to the release of a rye whiskey called Old Potrero, after the location of the Anchor Distillery in a secret corner of the Anchor brewery on Potrero Hill. The whiskey went into barrel in December 1994 and was first bottled and released in January 1996.

Old Potrero was followed by the release in April 1998 of a gin named Junípero, after the juniper berries that help define gin and Junípero Serra, the Franciscan missionary who figured so prominently in early California history. The demand for both Old Potrero and Junípero greatly exceeded

production, and this marked an auspicious beginning for what became the Anchor Distilling Company.

As he had with craft brewing, he had now revolutionized craft distilling. Today, what he did and his doing it twice is the object of a great deal of pride for Fritz Maytag. Each time he mentions this accomplishment, the satisfied hint of a triumphant smile can be seen on his face.

By the first decade of the new century, Maytag was ready to part with Anchor if the right new owner could be found, and in 2010, after looking at a lot of people, he found the men whom he described as "the right guys." The company was sold to Tony Foglio and Keith Greggor, formerly of Skyy Spirits, two men with long and successful résumés in the beverage industry and with genuine respect for the Anchor brand and its potential. This is illustrated by their having retained key personnel, such as brewmaster Mark Carpenter, who had been with Fritz Maytag since 1972.

Old Potrero and Junípero quickly became the cornerstones of a rapidly expanding spirits portfolio under the banner of the Anchor Distilling Company, a component of Anchor Brewers & Distillers.

At Anchor Brewing Company, Carpenter and the new owners reached into Anchor's past for inspiration for future projects. In 2010, they introduced Brekle's Brown, a 6 percent ABV brown ale inspired by and named for Anchor's founder. Two years later came 4.9 percent Anchor California Lager, based on the nineteenth-century lager of the Boca Brewing Company in the Sierra Nevada. In turn, Anchor joined other California breweries in the release of an IPA, rated at 6.5 percent ABV, in 2014.

Even as the new products were joining the portfolio, Anchor's new owners were looking further into the Anchor's future—and across town—to a twenty-eight-acre parcel of land a two-mile drive to the northeast on San Francisco's waterfront. Pier 48, owned by the Port of San Francisco and located just across McCovey Cove from the ballpark of the San Francisco Giants, became the nexus of what they imagined for Anchor in the twenty-first century.

The site was underutilized before the ballpark opened, and thereafter, it was used mainly—if at all—for parking, and there was an interest on the part of the Giants to develop it.

Even before the turn of the century, there had been a major effort to revitalize San Francisco's waterfront, and many of the unused or underused piers were being retrofitted and repurposed. Pier 39 had long ago been turned into a tourist destination, Pier 3 was being transformed into an office complex and Pier 15 was being developed as the new home of the Exploratorium,

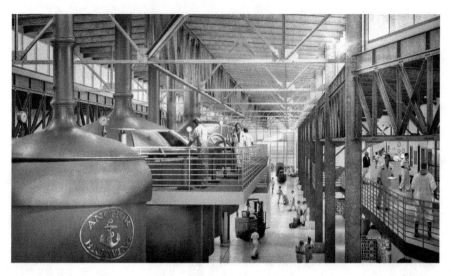

An artist's concept of the Anchor Brewing Company facility at Pier 48 near McCovey Cove on the San Francisco waterfront. *Courtesy of Anchor Brewing.*

San Francisco's hands-on science museum. Though the 180,000-square-foot building and the pier itself were in need of a seismic upgrade, Pier 48 was actually in better condition than most of the underutilized piers. Meanwhile, the Mission Bay area immediately south of Pier 48 was being transformed from a disused rail yard into a "city within the city" centered on the new sixty-acre University of California hospital and research campus.

Around the end of 2007, the developers who were hoping to be chosen by the Giants approached Fritz Maytag about building a brewpub and museum at Pier 48 as part of their idea for a development plan. Discussions ensued, but with the economic downturn of 2008, this notion went dormant until 2010, when the new owners revisited this idea, as well as an extensive program of cooperation and sponsorship with the Giants, as part of their growth plan. Anchor became a staple among the handles at the ballpark, the Giants logo appeared on Anchor packaging and Anchor later opened a beer garden at the Yard at Mission Rock, a "pop-up food and retail village" nearby.

As John Dannerbeck, a longtime Anchor veteran and now senior vice-president of Anchor Brewers & Distillers, explained to this author, the company now saw that there was potential in the twenty-eight acres at Pier 48 beyond just being the location of a brewpub and museum. It came to view Pier 48 as the answer to the need for a major expansion. Though the capacity of the Mariposa Street brewery had been enlarged from 107,000 barrels annually to 250,000, increasing demand was putting pressure on

available space. Looking deeper into the twenty-first century, Anchor was faced with the need for expansion, but looking into its past and present as a San Francisco company, it was clear that the expansion must happen within San Francisco. With this in mind, plans were made for a new 500,000-barrel brewery at Pier 48.

Just as such a brewery vastly expands on the notion of a mere brewpub, John Dannerbeck described plans to go well beyond a mere museum. Noting that San Francisco is one of the most popular tourist destinations in the world, he points out that the proximity of Pier 48 to downtown, the ballpark and the Mission Bay development gives the pier the potential to become one of the most popular tourist destinations in San Francisco. In addition to a production brewery that would triple Anchor's brewing capacity, the company foresees a world-class visitor experience that would handle one million people annually. He compares it to those popular visitor centers that have been created by Guinness in Dublin, Heineken in Amsterdam and Carlsberg in Copenhagen.

Foglio and Greggor envision creating a destination that would include the world's first Center of Excellence for Craft Brewers and Artisan Distillers. It would cater to the trade as well as to the public, with guest lecturers presenting programs related to brewing and distilling as well as on other topics related to the world of food and beverages.

For Anchor, this facility would be a far cry from the "medieval brewery" that Fritz Maytag took over a half century earlier. For San Francisco, it would underscore the status and the importance of the city as an international destination for those who pursue and appreciate the vibrant world of craft brewing.

Meanwhile, the evolution of Anchor can be seen as an allegory for the evolution of brewing in the early days nearly two centuries past—as well as for brewing during the craft brewing revolution of the twentieth century—when the brewers of San Francisco were true pioneers, proud to be making things up from scratch while armed only with their commitments to craftsmanship and their consumers. It is this legacy that survives in the twenty-first century.

No narrative purporting to tell the history of something so dynamic as brewing in San Francisco can conclude with any summary but "to be continued." As we interrupt—we can not and do not conclude—our story, we do so with the wistful prediction that some of those breweries about whom we have spoken in the present tense will fade away, as did their predecessors

throughout the nineteenth and twentieth centuries. One example is the Chapter 11 bankruptcy filing of Magnolia Brewing, which came at the end of 2015 just as this book was being prepared to go to press. Only time will tell whether we will look back on the demise of what had been a longtime icon of San Francisco brewing or whether Magnolia will continue forward. It does serve as a reminder that old favorites have faded in the past and that others will follow them in the future.

However, even with this turn of events, we must also add the confident and optimistic prognostication that others will survive and flourish *and* that new and exciting breweries will come to San Francisco.

It is no heedless hyperbole to assert that the *best is yet to come*.

Appendix I

Commonly Used Abbreviations

Abbreviations and acronyms are used infrequently in this book and are usually explained at the time and place where they are mentioned. There are three exceptions, very common industry abbreviations that are widely used without explanation.

alcohol by volume (ABV): This is the worldwide industry standard method for measuring and reporting alcohol content. By definition, it is the number of milliliters of pure ethanol (ethyl alcohol) present in one hundred milliliters of solution at twenty degrees Celsius or sixty-eight degrees Fahrenheit. The most accurate method of calculating ABV is to distill a spirit that contains all the alcohol in a given volume of beer and then to measure the alcohol using a hydrometer. The easier, and more commonly used, method is to measure the density of the wort, the unfermented liquid precursor to beer produced during brewing, and to compare this to the beer once it is fermented. *Proof* is a term used in the United States (and in the United Kingdom before 1980) to report the ABV of spirits. The proof is double the ABV. A spirit that is 50 percent alcohol would be called 100 proof. In some jurisdictions, but not in California, laws require alcohol content to be reported by weight (ABW) rather than by volume (ABV).

India pale ale (IPA): This is a type of ale that originated with British brewers during the early nineteenth century. It was so named because a high concentration of bittering hops were used as a preservative to permit it to be shipped to India, then a British colony, without spoiling. The style generally became a rarity during the twentieth century, but it has enjoyed

a tremendous revival, especially in California and the West, since the turn of the twenty-first century.

International Bitterness Units (IBU): This is the conventional one-hundred-point scale for measuring and reporting the bitterness of beer. On the scale, pale lagers generally have around ten IBUs, while most ales and craft lagers are in the thirty to fifty range. India pale ales are somewhat higher, and double IPAs closer to one hundred, the taste bud threshold. An alternate system not used in the United States is the European Bitterness Units (EBU) scale, which employs a different technical means of calculating and yields a slightly smaller number. In general, bitterness is calculated by using a spectrophotometer and solvent extraction to measure certain acids in the beer. It is an inexact science, given that perceived bitterness is highly subjective and may often be at variance with the IBU scale. Beers with a strong malt flavor may taste less bitter or less hoppy than a beer with the same IBU but that utilizes lighter malts.

Appendix II
MEASUREMENTS

The basic means of measuring beer in the United States are the pint at the retail level and the barrel at the industry level. Prior to the craft brewing revolution, beer was sold across American bars in a variety of glassware styles, but since the 1980s, the standard pint glass, a style borrowed from Britain, has become ubiquitous in the United States. This glass literally holds one pint of fluid, which translates to sixteen fluid ounces or 473 milliliters. The British pint glass was designed to hold one imperial pint or twenty imperial fluid ounces (568 milliliters).

The barrel is a widely used measurement for fluids in the United States and is used unofficially in the United Kingdom and elsewhere in the metric world. Confusingly, barrels have different values depending on contents and specific industries. In the United States, most liquid commodities are measured in barrels containing 31.5 US gallons (119 liters), though the oil industry uses barrels containing 42 US gallons (159 liters). Beer, however, is measured in barrels containing 31 US gallons (117 liters).

INDEX

A

Acme Brewing Company 28, 52, 54, 55, 60, 62, 63, 64, 65, 67, 68, 69, 70, 71, 72, 74
Adami, Johanas 23, 41, 104
Adams, Jacob 41, 42, 104
Ahrens & Company 40
Albany Brewery 27, 28, 33, 50, 52
Albion Ale and Porter Brewery 36, 37, 38, 39, 50, 52, 56
Albrecht, Joseph 23, 41
Allen, Joe 58, 75
Almanac Beer Company 108
American Railroad Brewery 29
Anchor Brewing Company 5, 36, 38, 39, 46, 50, 52, 58, 75, 76, 77, 78, 79, 86, 126, 128, 129, 130, 131, 143
Anchor Distillery 128, 129
Armstrong, Charles 24, 30, 42

B

Bancroft, Hubert Howe 15, 16, 17, 18, 19
Barrel Head Brewhouse 122, 123
Bartlett Hall 118, 119

Baruth, Ernst 39, 51
Bavaria Brewery 44, 50
Bavarian Brewery 23, 44
Bay Brewery 30, 40, 43
Bay View Brewing Company 53
Beach Chalet Brewery and Restaurant 87, 88, 89, 90, 98, 101, 109
Belmer, Henry 43
Berlin Brewery 24
Berliner Brewery 31
Billy the Brewer. *See* McGlone, William
Black Hammer Brewing 116, 117, 118
Black Sands Brewery 120, 121, 122
Boca Brewing Company 31, 129
Bohemian Distributing Company 64
Bon Marché Brasserie & Bar 126
Borthwick, John David 21
Brekle, Gottlieb (George) 38, 39, 43, 129
Brewer-Hay, Richard 97, 109, 110
Brewers' Association 45
Brewers' & Maltsters' Union 45
Broadway Brewery 23, 33, 41, 50, 52, 54, 104
Brood, Charles 29
Brooklyn Brewery 47, 52
Brown, John Henry 17, 18, 19
Buchanan, Bennett 119

Bull, William 17, 19, 21, 24
Burnell, John Hamlin 36, 37, 38, 79, 87

C

Café Pacifica 83, 119
California Brewery 17, 19, 47, 52
California Brewing Association 28, 54, 55, 60, 63
California Brewing Corporation 62, 64
Camusi, Paul 43
Carner, Ambrose 20
Casey, Connor 30, 110, 111
Casteel, Andrew 120
Catalana, Justin 124
Catalana, Tyler 124
Caveney, Kelly 30, 110, 111
Cellarmaker Brewing Company 30, 110, 111, 112, 115
Center of Excellence for Craft Brewers and Artisan Distillers 131
Cervecería MateVeza 105, 106, 107
Champion Brewery 29
Cherniss, Hilary 124
Chicago Brewery 40, 47
Cincinnati Brewery 26, 28
Citizen Fox 126
Cold Spring Brewing Company 96, 97
Conro, B.F.D. 23
Consumers Brewing & Bottling Company 50
Cutti, Phil 107, 117

D

Dannerbeck, John 130, 131
Denzler, Jacob 41
Deorsey, Aron 90
Dobel, Brenden 86
Dogpatch 92, 93, 94, 112, 113, 115
Durkin, Anthony 24, 30

E

Eagle Brewery 6, 47, 50, 52, 58
Eldo's Grill and Microbrewery 100
Elizabeth Street Brewery 97, 109

El Rey Brewing Company 58
Emde, Cole 120, 121
Empire Brewery 17, 19, 21, 24, 28, 33, 35, 42
Enterprise Brewery 40, 50, 52
E&O Trading Company 83, 119
Erfelding, John 40
Eureka Brewery and Distillery 23, 26, 34

F

Falstaff Brewing 70, 72, 73
Fauss & Kleinclaus 40
Fenson, Sarah 115, 116
Figone, Jeff 99
Figone, John 99
Foglio, Tony 129, 131
Fort Point Beer Company 124, 125, 127
Foto, J.S. 64
Frauenholz, Philip 23, 44
Freccia, Nico 6, 94, 95, 96, 97
Fredericksburg Brewery 41, 44, 47, 52, 56, 70
Frederick, William 40
French, Andy 104
Furman, Jim 116, 117, 118

G

General Brewing Corporation 66, 67, 69, 72, 73, 120
Gilliland, Andy 120, 121
Globe Brewing Company 62
Glueck, John 28, 29
Gobbo, Ed 113, 115
Golden City Brewery 38, 39, 43
Golden Gate Brewery 29, 33
Golden Gate Flour Mills 23
Golden Gate Park Brewery 99, 100
Golden West Brewing Company 52
Gordon Biersch brewery-restaurants 82, 83, 84, 100
Gordon, Dan 83
Greggor, Keith 129, 131
Grossman, Ken 43, 80
Gundlach, Jacob 23, 44

H

Hagemann Brewing Company 28
Hagemann, Frederick 28, 50, 52
Hamm's Brewing Company 71
Hansen, Charles 28, 29, 41
Happy Valley 24, 26
Harmonic Brewing Company 113, 115
Hayes Valley Brewery 40
Headlands Brewing Company 107, 117
Hemrich, Louis 53, 59
Henry Weinhard Brewery 54
Hermannsson, Bryan 117, 118
Hess, Christian 24
Hibernia Brewery 6, 30, 33, 41, 42,
 43, 50, 52, 58
Hicks, Aaron 120
Higgins, Rich 100, 126
Hildebrandt & Company 40
Hoelscher, August 26
Hoen, Francis G. 17, 18, 19, 20, 21,
 23, 81, 103
Hofburg Brewery 47
Hofner & Company 29
Hopkinson, Ivan 122, 123
Horn, Patrick 107, 117
Huth, Carlton 53, 104

J

Jackson Brewery 40, 52
Jaiger & Company 24
John Wieland Brewery 51
John Wieland Brewing Company 45,
 47, 50, 56
Joseph, G.F. 20

K

Kitchen, Greg 112, 113
Koster, Adam 24
Krahenberg, Gottfried 41
Kraus, Joseph 51, 58, 128
Kronenberg, Frederick 40

L

Lafayette Brewery 29, 42
Lang, Adolph 41
Lange, Klaus 82, 83, 105
Laughing Monk Brewing 120
Lawrence, Chris 41, 53, 104
Lesynsky, Julius 45
Lion Brewery 22, 43. *See* also Red Lion
Local Brewing Company 115, 116
Long, Regan 115, 116
Los Angeles 64, 65, 69, 70, 71, 72, 94
Lucky Lager 66, 67, 68, 69, 72, 73,
 74, 120
Lyon & Company 24, 28

M

Magnolia Gastropub and Brewery
 87, 90, 91, 92, 93, 94, 98, 112,
 113, 132
Maia, Taylor 98
Malloy, Timon 88
Marks Brewery 30
Marks, Samuel 30
Martin, John 82
Martin, Reid 82
Mason, John 23, 26, 34, 47
Mason's Brewery 23
Maytag, Fritz 5, 76, 77, 78, 79, 80,
 103, 128, 129, 130, 131
McAuliffe, Jack 37, 79, 80
McGlone, William 15, 16, 17
McLean, Dave 91, 92, 93, 94, 112
Megquier, Mary Jane 21
Meltzer, Charles 29
Mendocino Brewing 80, 105
Meyer, Adam 26, 28
Meyer, August 51, 128
Mikkeller 107
Miller Brewing 72, 74
Mill Valley Beerworks 107, 124
Milwaukee Brewery 30, 40, 44, 50, 52,
 57, 58, 71, 73
Mission Brewery 23
Mission Street Brewery 24, 30

N

National Brewery 28, 29, 41, 52, 60, 65
National Brewing Company 54
New Albion Brewery 37, 79, 80
New York Brewery 29, 40
North Beach 23, 24, 29, 76, 100
North Beach Brewery 40
North Coast Brewing Company 74
North Star Brewing Company 46, 47, 50, 52
Nunan, Matthew 30, 42, 43

O

Oakland Brewery 47
Old Bus Tavern 119, 120
Olympia Brewery 52, 53
O'Sullivan, Shaun 6, 94, 95, 96, 97, 98, 109, 110

P

Pabst Brewing 45, 61, 69, 70
Pacific Brewery 47
Pacific Brewing Laboratory 117, 118
Pacific Brewing & Malting 53, 56, 59, 70, 104
Paul, Allan G. 81, 83, 103
Pete's Brewing Company 116, 117
Pfether, Thomas 29
Philadelphia Brewery 25, 26, 28, 33, 34, 35, 40, 41, 44, 45, 51, 95
Pine Street Brewery 109
Pizza Orgasmica & Brewing Company 98, 99
Postel, Arnold 41
Postel, Rudolf 41
Potrero Brewing Company 98
Prohibition 6, 38, 43, 46, 49, 52, 53, 54, 55, 56, 59, 60, 62, 66, 75, 77, 80, 84, 87, 94, 103, 104
Puget Sound Brewery 53

R

Rainier Brewery and Rainier Brewing Company 53, 59, 60, 67, 70, 71, 73
Red Lion Brewery 23, 43, 58
Rittenmayer, Jacob P. 52
Russian Hill 29, 38, 39, 50, 51

S

San Francisco Breweries, Ltd. 47, 50, 51, 52, 55
San Francisco Brewers Guild 83, 87, 100, 122, 127
San Francisco Brewery 23
San Francisco Brewing Company 81, 83, 84, 100
San Francisco Brewing Corporation 57, 61, 62, 63
San Francisco Giants 95, 129
San Francisco Stock Brewery 29, 33, 34
Sankt Gallen Brewery 83
Schinkel, Otto, Jr. 39, 51
Schlitz Brewing 45, 61, 69, 71, 73
Schmidt, Leopold F. 52, 53
Schnebeck, Mike 124, 127
Schneider & Wachter 43
Schuldt, William 52
Schultz, Frederick 44
Schultz, Louis 44
Schuppert, Adam 17, 19, 21, 23
Schuster, Karl F. 64
Schwartz, Joseph 40
Schwarze, Hermann 29
Sciascia, Tim 30, 110, 111
Seacliff Café Restaurant and Vest Pocket Brewery 82
Seattle Brewing & Malting 53, 59
Sick, Emil 59, 60
Sierra Nevada Brewing 43, 80, 96, 129
Silberstein, Ron 85, 86
Simpson, Jimmy 120
Smokestack 92, 93, 94, 112
Social Kitchen & Brewery 99, 100, 101, 126

Southern Pacific Brewing Company 41, 53, 103, 104, 105
Southpaw BBQ 107, 108
South San Francisco Brewery 26
Speakeasy Ales & Lagers 86, 87, 88, 94, 98, 101
Specht, Jacob 23, 41
Spreckels, Claus 27, 28, 33
Steelhead Brewing Company 98
St. Louis Brewery 43, 52
Streuli, John 29
Stuber, Jacob 43
Sturdavant, Kim 100
Sulitz, Herman 23, 31
Sunset Reservoir Brewing 124
Swiss Brewery 29

T

Theodore Hamm Brewing Company (Hamm's) 70, 71, 72, 73, 74
ThirstyBear Brewing Company 85, 86, 98, 100, 101, 110
Tietjen, Henry 51, 128
Törnberg, Carl 47, 50, 52, 58
Toronado 120
Triple Voodoo Brewery 112, 113, 114
Truppelli, Gar 88
Truppelli, Lara 88
21st Amendment Brewery (21A) 6, 94, 95, 96, 97, 98, 101, 109, 110
Twenty Tank Brewery 82, 83

U

Union Brewery 24, 33, 47
Union Brewing Company 47, 50
Union Brewing & Malting 52, 54
United States Brewers' Association 51
United States Brewery 40, 47, 50

V

Verna, Jon 113, 115
Vitale, Frank 64

W

Waldo Springs 23
Walmuth, Henry 40
Wanemacher & Kronenberg 40
Washington Brewery 23, 33, 52
Weikert, Albert 43
Wells, Elizabeth 107, 108
Weshnak, Aaron 124
Weyand & Kasche 30
Whiskey Springs 23
Wieland, John 24, 25, 26, 27, 28, 33, 34, 44, 95
Willows Brewery 34, 40, 47, 50, 58
Woods, Jim 105, 106
Wreden, Claus 23, 52, 54
Wunder Brewing Company 44, 50, 52, 100
Wunder, John 100

Z

Zirinsky, John 119, 120

ABOUT THE AUTHOR

B ill Yenne is the author of ten novels and more than three dozen nonfiction books. Among his most recent books on beer and brewing history is *Beer: The Ultimate World Tour*, which *Gothic Epicures* named as the Drink Book of the Month and was described as "gorgeous" by Natalie Cilurzo of Russian River Brewing, "beautiful" by Sam Calagione of the Dogfish Head Craft Brewery and "brilliant" by

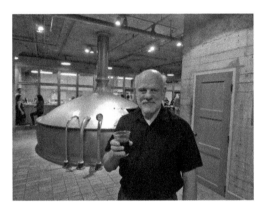

The author during a visit to the Anchor Brewing Company. *Mike Bolos photo.*

Fergal Murray, the master brewer at Guinness in Dublin. Murray goes on to say that Yenne's "writing style is stunning."

The two men met when Yenne was writing *Guinness: The 250-Year Quest for the Perfect Pint*, a book that is listed among the top business books of the year by *Condé Nast Portfolio Magazine*, which made it the top pick for "Cocktail Conversation." Says *World Business* magazine, "This is a thoroughly enjoyable, complete chronicle of a great beer business."

Among other Yenne books on beer and brewing history are *The American Brewery, Great American Beers: Twelve Brands that Became Icons, Beers of North America,*

Beers of the World and *Beer Labels of the World*. He has also contributed articles to *All About Beer Magazine* and has hosted numerous beer tastings throughout the Unites States. He was a member of an elite panel chosen to select the beers to complement each course of a formal dinner held at the Oldenberg Brewery. Afterward, Jay Maeder of the *New York Daily News* described his choice of a beer to accompany the entree of Soused and Stuffed Chicken Breast Marinated in Mustard Sauce as perfect.

Bill Yenne has discussed brewing history as a featured guest on the History Channel's *American Eats* program and on XM Satellite Radio and Podcast. He has also appeared in televised documentaries broadcast on the History Channel, the National Geographic Channel, C-SPAN and ARD German Television.

He has lived in San Francisco continuously since before the beginning of the craft brewing revolution and has followed its progress with immense personal and professional interest. He is on the web at www.BillYenne.com.

CPSIA information can be obtained
at www.ICGtesting.com
Printed in the USA
LVHW080744301219
642040LV00002B/49/P